IMAGES
of America

ROCK ISLAND COUNTY

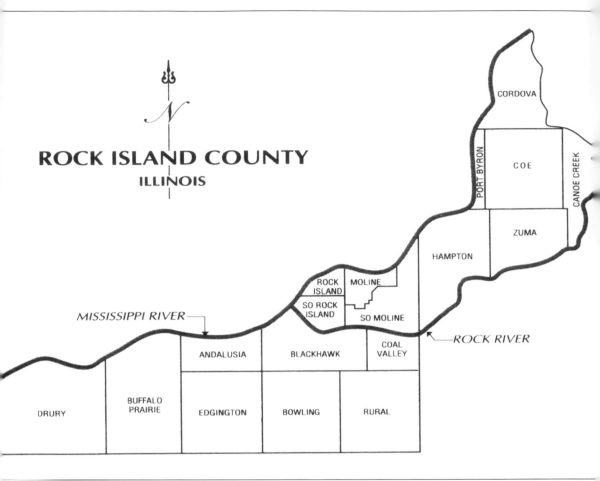

ROCK ISLAND COUNTY
ILLINOIS

N

CORDOVA

PORT BYRON

COE

CANOE CREEK

ZUMA

HAMPTON

MISSISSIPPI RIVER

ROCK ISLAND

MOLINE

SO ROCK ISLAND

SO MOLINE

ROCK RIVER

ANDALUSIA

BLACKHAWK

COAL VALLEY

DRURY

BUFFALO PRAIRIE

EDGINGTON

BOWLING

RURAL

To say that Rock Island County has a unique shape would be an understatement. It received its odd shape as the result of constant realignment of counties formed prior to Rock Island's creation in 1831. It was not until 1832 that Rock Island County's boundaries were conclusively established, bounded on the south by another county's border, on the east and west by rivers, and on the north by a slough.

On the cover: Before modern machinery, crop harvesting was not an easy task. Grain was cut, bundled, and stacked to dry, all by hand. Threshing the grain required gathering and loading bundles into a wagon and hauling the wagon to a threshing machine. The bundles were then placed into the thresher by hand. This 1892 photograph shows a threshing crew on the Herman Bracker farm in Coe Township. (Courtesy of the Rock Island County Historical Society Library.)

IMAGES
of America

ROCK ISLAND COUNTY

David T. Coopman

ARCADIA
PUBLISHING

Published by Arcadia Publishing
Charleston SC, Chicago IL, Portsmouth NH, San Francisco CA

Printed in the United States of America

Library of Congress Catalog Card Number: 2007943635

For all general information contact Arcadia Publishing at:
Telephone 843-853-2070
Fax 843-853-0044
E-mail sales@arcadiapublishing.com
For customer service and orders:
Toll-Free 1-888-313-2665

Visit us on the Internet at www.arcadiapublishing.com

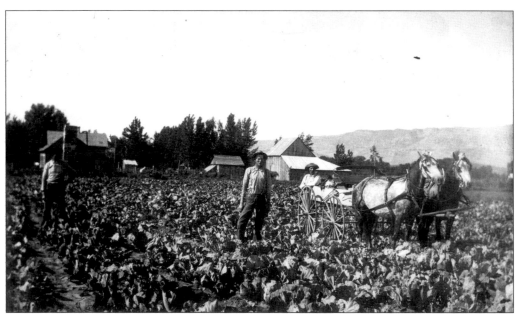

While not a mainstay agricultural product in the county in modern times, tobacco was an important cash crop in the late 1800s. With three cigar manufacturers in the county and several more across the river in Iowa, growers had a ready, close market. Native Americans brought tobacco to the area and taught settlers in its use, as it was thought to have miraculous healing powers. How erroneous that was.

CONTENTS

ACKNOWLEDGMENTS

This volume provides an overview of a rich history of rural life, industrial and urban development, and a look at the activities that made up the quality of life in Rock Island County. While it is in no way a complete history, it does offer a cross section of what made this area an important commercial success and an exciting place to live.

Without the help of many people, this book would not have been possible. I am indebted to the following for their contributions of photographs, information, and encouragement: the staff of the Rock Island County Historical Society Library, including Joyce Hanna, Kathleen Seusy, Phyllis Witherspoon, Kathryn Felsman, Shirley Ricketts, Lois Black, Linda Polich, Lois Mary McCarthy, Mary Rogers, Janet Meyer, Merredith Peterson, Barbara Sharp, Carol Kroeger, and Orin Rockhold; Ted Gerstle, Arcadia Publishing; Stephanie Nelson; Dr. Curtis Roseman; John Wetzel; Marcia Anderson Wetzel; Dennis Witt; Beverly Coder; Jack Coder; Stan Leach; Earl "Buck" Wendt; Chuck Hoaglund; Ron Chappell; Fred Marzolph; Willie McAdams; Harold Swanson; Ben McAdams; Junior McAdams; Sam Hutchinson; Bill Coopman; Dr. Al Zimmer; Steve Blaser; Ed Simpson; John Flambo; George Kirk; *Dispatch/Argus*; Gail Levis, Modern Woodmen of America; Rita Toalson and Cynthia Stoner, Royal Neighbors of America; Jennifer Malone, Rock Island Arsenal Museum; Main Camera Shop; Center for Belgian Culture; LRC Development; Coal Valley Library; Moline Second Alarmers; and Bob Engstrom, Mutual Wheel Company.

All photographs, unless otherwise credited, and major research sources are from the files of the Rock Island County Historical Society Library, including the photographic collections of John Hauberg, Charles Ainsworth, Kenneth Brostrom, Marjorie Carlson, Robert Bouilly; James Haymaker, U.S. Army Corps of Engineers; and the City of Rock Island. Some railroad information was provided through the courtesy of the Steve Llanso Locobase and Allen Stanley.

INTRODUCTION

The Illinois legislature created Rock Island County in 1831, yet historical events leading to that formation trace back as early as the American Revolution and the War of 1812.

The Sauk and Mesquakie Indians, many of whom had allied with the British by the time the Revolutionary War had reached the area, inhabited the land that became the county. Colonial militiamen chased British sympathizers to the Native American village of Saukenuk near the mouth of the Rock River and burned the village. This was the westernmost battle of the Revolutionary War.

After the war, and as various territories were ceded to the federal government, an 1804 treaty had the Sauk and Mesquakie tribes relinquish their lands east of the Mississippi River between the Illinois and Wisconsin Rivers. The treaty did give the Native Americans the right to continue to live there as long as the government owned the land. This treaty was a point of contention for years, as the Sauk warrior Black Hawk felt that the Native American signers did not have the authority to do so, and therefore, the treaty was null and void.

The War of 1812 caused a deeper split in loyalties among the Native Americans. Most Mesquakie and many Sauk Indians were sympathetic to the Americans and wanted no part in the war. They moved farther west. The Sauk Indians who remained followed the lead of Black Hawk and became known as the British Band.

Black Hawk and his followers lived peacefully until 1814. At that point, they were involved with two small battles. The first became known as the battle of Campbell's Island. The British Band defeated Lt. John Campbell and his command on the shore of a small island just off today's Hampton Township. Twenty soldiers, a woman, and a child were killed in that battle. The second skirmish caused Maj. Zachary Taylor and his American troops, sent to retaliate against Black Hawk for Campbell's defeat, to retreat back down the Mississippi River to a point near the southeastern tip of Iowa.

Fort Armstrong was established on Rock Island in May 1816 to protect the fur-trading business from intertribal Native American squabbles and from the British traders who still traveled the area. By the early 1820s, riverboats began navigating the waters of the upper Mississippi River to supply forts that had been built north of St. Louis. Low water and the Rock Island Rapids made the trips treacherous. But boatbuilders modified their hull designs, and steamboats were soon plying the river in large numbers. Besides supplies for the forts, the boats brought white settlers.

The government began selling land to the settlers, and squatters began occupying other Native American land. The land issue and intertribal conflicts ignited the Black Hawk War in 1832. With the defeat of Black Hawk near Victory, Wisconsin, nearly all the former Native American territories were finally ceded to Illinois. The conclusion of the Native American hostilities meant the county's boundaries could finally be fixed, and it also brought hundreds of settlers into the county to form settlements and villages.

While new settlers to the area were buying land and establishing homesteads, the county went about the business of setting up a seat of government. Factions from Farnhamsburg and Hampton vied for the vote to become the county seat. Farnhamsburg became the temporary seat of government in 1833. In 1835, land was purchased several miles to the west of Farnhamsburg to build a courthouse. A town was platted and was named Stephenson. Several years later, the town was renamed Rock Island and included Farnhamsburg.

Throughout the county, other settlements began to grow into villages and towns. Each had a particular draw. Whether it was soil for farming, coal for mining, stone for quarrying, lumber for cutting, or water for transporting or powering, the county began to flourish.

Some of the towns along the Mississippi River began to turn into business and industrial centers, thus becoming full-fledged cities. By the early 1850s, the railroad had come to town. The tracks of the Chicago, Rock Island, and Pacific Railroad had advanced as far as the city of Rock Island. But to move farther west, a bridge was needed to cross the river. The first railroad bridge at any point over the Mississippi River opened on April 21, 1856, despite opposition from river interests. When the steamer *Effie Afton* struck the bridge two weeks later, young Abraham Lincoln represented the railroad in the ensuing lawsuit by the steamship companies. Regardless of its onerous introduction to crossing the river here, the Chicago, Rock Island, and Pacific Railroad eventually established a major repair shop and sorting yard facility at Silvis in the early 1900s.

Besides offering easy transportation, the Mississippi River provided the means for cheap power along its banks. Men with names like Sears, Spencer, White, and Davis began building waterpower facilities to run the machines of new industry.

Brothers-in-law Frederick Denkmann and Frederick Weyerhaeuser commenced buying up small, financially struggling sawmills. Their ingenuity and resources helped turn the county into a giant lumber center that kept many steamboats busy pushing log rafts on the Mississippi River.

The lure of cheap power brought blacksmith John Deere to Moline in 1846. While he did not invent the plow, he did create the first self-scouring plow, which made the farmer's task of tilling the rich, sticky, Midwestern soil so much easier. Other men soon followed to start their farm implement, wagon, and carriage firms in Rock Island, Moline, and East Moline. More industries like foundries, machine shops, and component manufacturing were founded to augment the implement makers.

When the automobile began to replace horses, wagons, and carriages, some of those same firms began manufacturing automobiles. At the height of manufacturing, 16 brands were manufactured in Rock Island County before the Great Depression.

Since the island of Rock Island was owned by the government since the establishment of Fort Armstrong, the army officially created the Rock Island Arsenal in 1862. By World War II, the arsenal employed more than 11,000 in the manufacturing of armament, tanks, gun carriages, and recoil assemblies and today serves as a storage and distribution depot for ammunition and other military supplies. It is also home to several supply commands.

The smaller communities were farm-service hubs, but Coal Valley and Carbon Cliff became coal-mining centers. Cordova and Port Byron produced some of the finest lime found anywhere. Hampton and Andalusia were major ferry ports for settlers heading west and steamboat landings for people and goods.

Thanks to all this industry and agriculture, the county received another reward: immigrants. The German, Belgian, Swedish, Greek, Irish, and Mexican people all came here to work the sawmills, implement companies, railroads, mines, and farms. They received a better life than what they might have had in the "old country," and the county received the benefit of their labor, customs, and the cultures they brought with them.

Through consolidation, downsizing, and a global economy, the farm implement business no longer dominates the economy of Rock Island County. But a vibrant future remains, built on the history of the past.

One

THE RURAL HISTORY

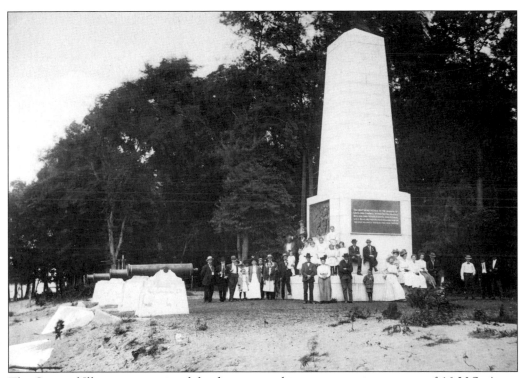

The State of Illinois appropriated funds to erect this monument in memory of 16 U.S. Army regulars, four Army Rangers, and two civilians killed during the battle of Campbell's Island in 1814. Native American chief Black Hawk led 200 Sauk and Mesquakie Indians who were supportive of British troops against U.S. forces led by Lt. John Campbell. The monument, located on the island named after Campbell, was dedicated in 1908.

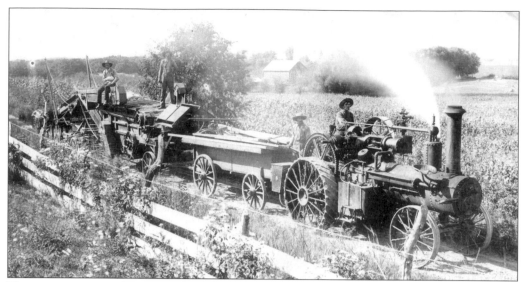

This is not a tractor. It is a portable steam engine, most likely a Peerless steam engine, and it is pulling a wagon and threshing machine in this 1890 photograph. Since many farmers had yet to mechanize, they hired the Walther-Wainwright crew to assist with the threshing operation. Threshers, also called separators, separated the grain from the straw and discharged the grain by auger into an adjacent wagon.

Farmers line up at the Zuma Creamery, owned by Sylvester Dailey, to drop off their cans of milk. Note that some wagons had several milk cans. Usually farmers who lived a few miles from the creamery picked up other farmers' milk along their way to earn a little extra money for delivery. Because home separators had already separated the cream, much of this milk was processed into skim milk.

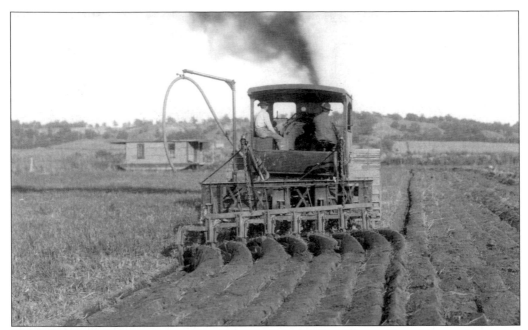

The lowland between the Mississippi River and the bluffs of Drury Township was known as "the Bay." The moist soil in this area was called gumbo and was worked in the fall rather than springtime. Walt Ziegenhorn plowed this soil with his Avery steam tractor. The hanging hose is used to replenish boiler water from a tender. Note the houseboat resting in the background. (Courtesy of Orin Rockhold.)

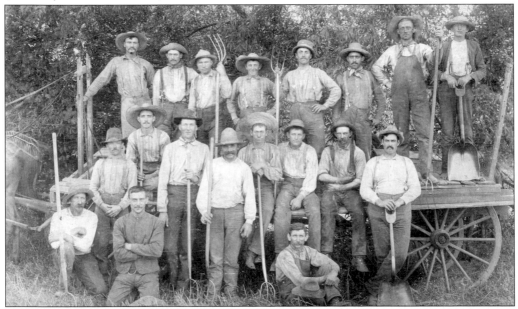

A group of neighbors poses for this 1894 photograph on the farm of Marx Hauberg in Coe Township before beginning their work of gathering bundles of dried crops for the threshing machine. The tough work of hand cutting and bundling the crops into shocks had already been completed. Payment for the neighboring farmers' services was usually in the form of a hearty dinner and helping them with their threshing.

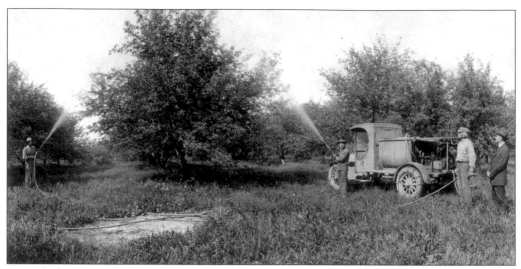

Instead of the usual farm crops, Bowling Township farmers leaned toward apples, grapes, berries, and potatoes. Mechanized spraying for pest control was a boon over the slow, labor-intensive hand-spraying method of the very early 1900s. This photograph from about 1920 illustrates the ease farmers had using modern spraying equipment. While unidentified, this orchard may have been in rural Milan or near Reynolds in Edgington Township.

Look at any map of Illinois and Rock Island County's location can easily be spotted where the Mississippi River runs east to west—from a point just downstream from Port Byron to a point at the northwest corner of Drury Township opposite Muscatine, Iowa. In this 1910 photograph from a hill above Rapids City, that bend can clearly be seen.

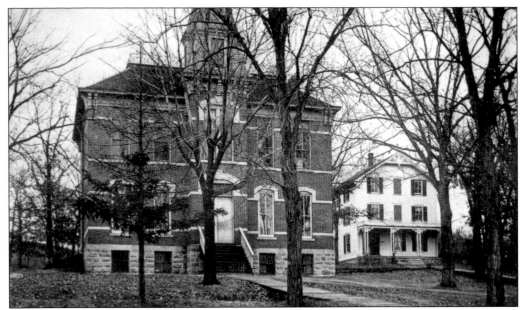

Opened in 1883 as a college preparatory school with Christian ideals, the Port Byron Academy (left) was operated by the Congregational Church and Beloit College. By 1896, Beloit College was the sole operator and provided the instructors. A dormitory for boarding students was added in the early 1900s. The academy closed in 1918, and the building became the home of the Port Byron High School in 1923.

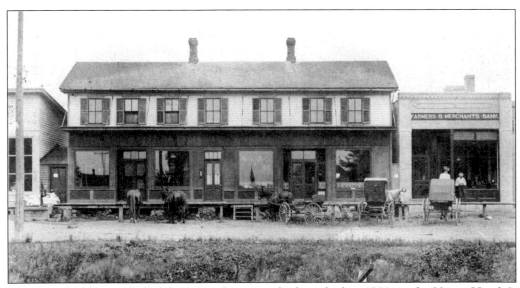

This large building on Hillsdale's Main Street was built in the late 1800s as the Union Hotel. It later held a drugstore, a barbershop, and a café. On the right is the Farmers and Merchants State Bank, organized in 1903 and incorporated in 1920. It was unique in that it was reported to be the only bank in the county that remained open during the dark days of the Great Depression.

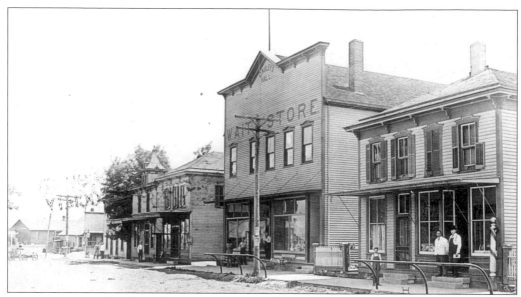

Incorporated in 1894, Reynolds prospered with the aid of the Rock Island Southern Railway. This photograph from about 1910 shows the south side of Main Street, looking southeast. The Reynolds Hotel is seen at the far end. Gauley Hall was the home of Wait's Store, and the second floor contained the Reynolds Opera House. Today the municipal building and the 133-year-old Hamlet Mutual Insurance Company stand where Wait's and the barbershop once stood.

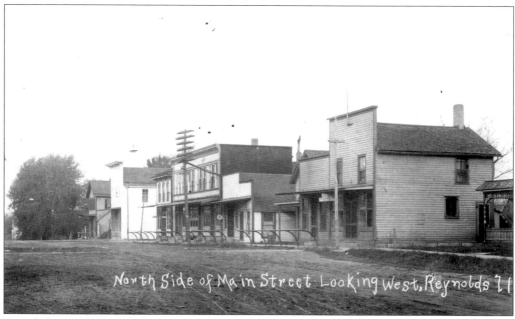

From left to right, a harness shop, a clothing store, a bank, the *Reynolds Press*, doctors' offices, and the Ideal Restaurant line the north side of Main Street in Reynolds. When Philander Cable agreed to run his railroad from Rock Island through the new village to the mines in Mercer County, Elisha Reynolds was hired to survey and build the line. Reynolds was a bridge and railroad contractor, and the town was named in his honor.

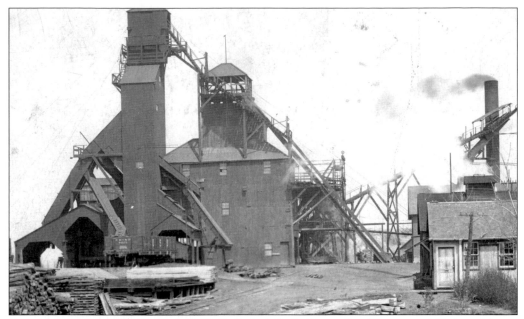

Formed in 1856 by Charles Buford, N. B. Buford, S. S. Guyer, Ben Harper, and Holmes Hakes, the Coal Valley Mining Company was also responsible for laying out the town, naming it, and building many of its first homes. Besides having several large mine operations at Coal Valley, the company also had this mine operation located on the Rock Island–Mercer County line. (Courtesy of Dennis Witt.)

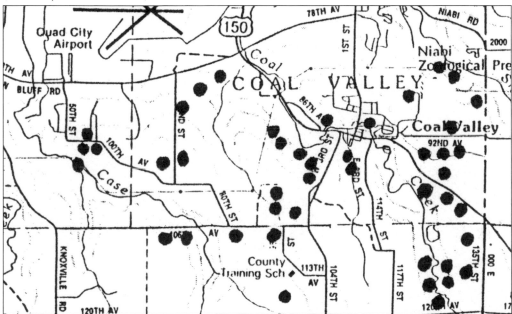

Coal mines were operated throughout Rock Island County from the mid-1800s through the early 1900s. A search of the Illinois State Geological Survey lists well over 100 mines, but that only includes the mines that were registered; many more were never recorded. While this map does not show each individual mine, it does illustrate the number of mine locations in the Coal Valley area and why Coal Valley got its name.

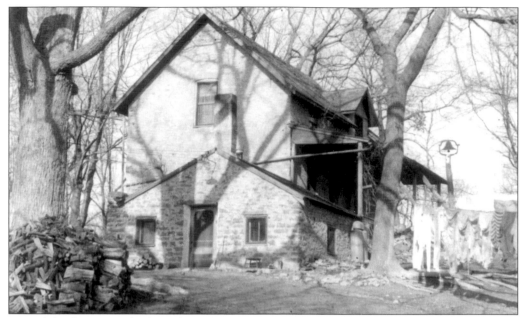

Part of this house was built in the mid-1800s and was owned by Dr. Andrew Bowman, pioneer physician and shopkeeper in Andalusia. Length was added and a second story built over the original construction around 1900. Known for his generosity as a merchant and full of good humor, Bowman eventually moved to both California and Mexico before returning to Iowa to continue his medical practice.

A building constructed of homemade brick that has stood for over 150 years is fairly uncommon. But that is exactly how the Deacon William Pearsall house in Coe Township was built. Constructed in 1853, the clay was ground by oxen and then kilned in a pit dug by the owner next to the house. Later in its life, it served as a stagecoach stop on the way to Dixon.

George Marshall, a son of Cordova's first postmaster, gave up farming and built a hotel in the village. Called the Marshall House, it operated for many years. Over time, the hotel business dropped off and the building was converted to a residence. The Marshall family retained ownership, and Marshall's granddaughter used it as a summer and vacation home. As of the 1980s, the home still remained with family descendants.

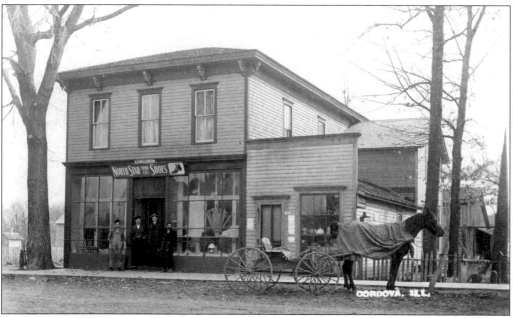

Cordova residents did not have far to go to buy their shoes. This photograph from about 1900 shows Erastus Williamson's store that proudly featured North Star Shoes, as well as a variety of general merchandise. The store burned down in 1912, and George Shumate opened a grocery and implement business on the site. In addition to groceries, hardware, and implements, Shumate also sold Plymouth and DeSoto automobiles at the store.

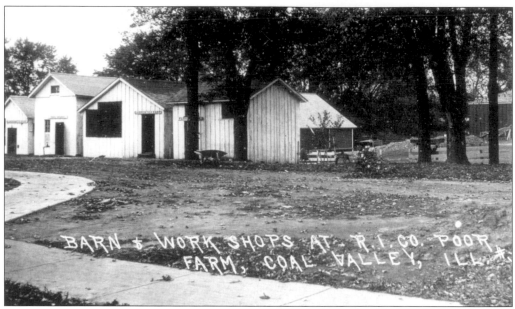

Located in rural Coal Valley, the county poor farm was established in the late 1880s. The facility was established to house the elderly, infirm, and children with no other place to go. Able-bodied residents were expected to assist with the operation of the farm. As other agencies began assisting the less fortunate, the county closed the farm and opened the Oak Glen Nursing Home on the site in 1953.

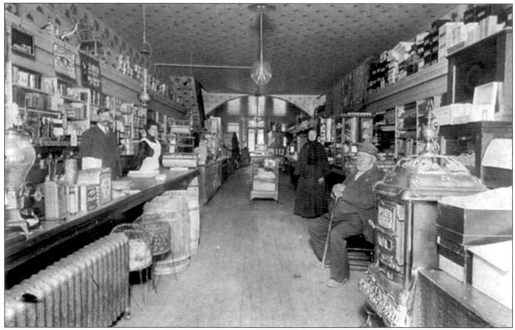

Coal Valley resident Gustave Krapp Sr. opened this general store in 1889. In 1891, Krapp sold the store to his son Gustave Jr. and the son's brother-in-law Thomas Lees. The Krapp and Lees Store operated until 1920. The Krapp and Lees name continued with a lumber, hardware, and implement business until the early 1940s. (Courtesy of the Coal Valley Library.)

Officially called the Illinois and Mississippi Canal, the Hennepin Canal was built to tie the Illinois and Mississippi Rivers together and save nearly 500 miles of river travel. It was the first canal to be built of concrete without stone-cut facings. Construction began in the early 1890s and was completed in 1907. This photograph was taken in 1895, as construction began above Milan.

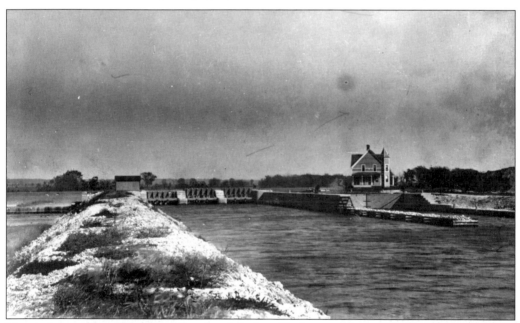

Here is the completed Hennepin Canal with lock and lockmaster's house at Milan. Schoolchildren in towns along the canal were dismissed to watch the first steamer travel the canal. By the time the canal was completed, freight barges had become too large for the canal to handle, and river traffic had declined because of the cheaper shipping rates offered by the railroads. The canal's commercial use ended by 1940.

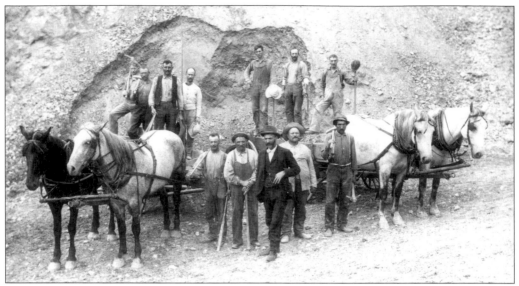

The bluffs between Port Byron and Cordova offered some of the best limestone in the area from which to make white lime. Much of it came from quarries owned by the Metzger Lime Company, which owned two kilns in Port Byron and four in Cordova. This photograph from about 1900 shows a loading crew at the Metzger quarry. The gentleman in the dark suit is Homer Metzger, the quarry manager.

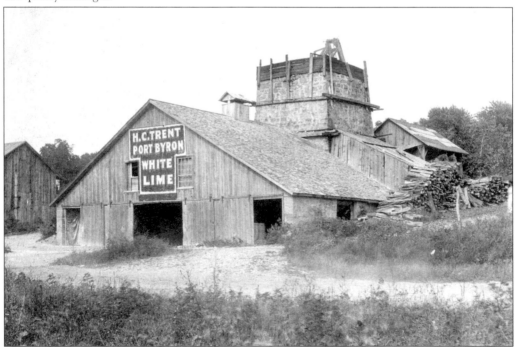

After long hours and great heat in a kiln, limestone was turned into white lime. When cooled, the lime was placed into barrels for shipment via steamboat or train. Quality white lime was in high demand for stucco and plaster. The Henry Trent White Lime Company was one of several in Port Byron. Note the kiln chimney and the elevator used for dropping the limestone into the kiln.

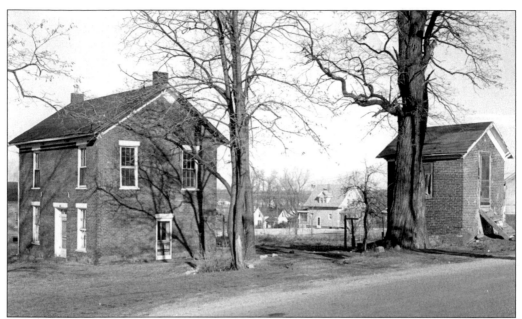

The building on the right was the East Moline area's first post office. Located in Watertown, it was a former smokehouse owned by Henry C. McNeal, who built the house on the left in the early 1800s. McNeal owned much of the property running upriver from Watertown, including land that became Hampton. Hampton, established in 1837, was originally named Milan but was changed to Hampton by the post office in 1838.

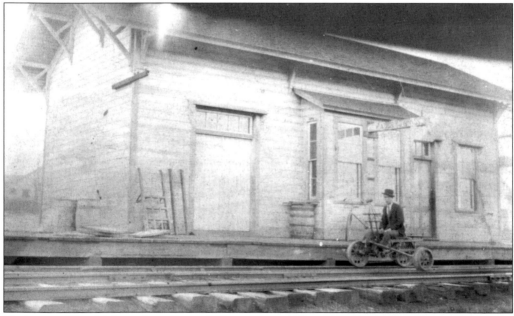

Now part of East Moline, the village of Watertown was first platted in 1857 and was organized in May 1905. The Chicago, Milwaukee, and St. Paul Railroad served the Hampton Township coal mines and established a depot at Watertown. Henry C. McNeal, shown in this photograph, was the manager of the depot. Note the interesting one-man inspection vehicle. McNeal was also a village trustee. (Courtesy of Beverly Coder.)

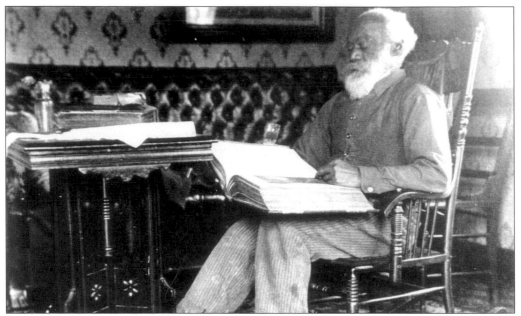

A Port Byron veterinarian with the flowing white hair and beard, Charlie Wilson was born into slavery in 1836. Well known and a devoted supporter of the town, he lost his leg at a Fourth of July celebration while lighting off a cannon round that contained a double load of gunpowder. Wilson was also the grandfather of Rock Island actor Tim Moore, who played George "Kingfish" Stevens on television's *Amos 'n' Andy* series.

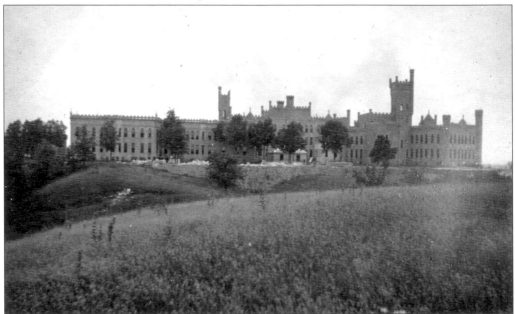

With the donation of 400 acres of land by the county board, construction began on the Western Hospital for the Insane in 1896 at Watertown. While its construction was fireproof, its architecture gave the appearance of medieval castles complete with turrets. The complex seemed rather foreboding for the medicine practiced there. The institution was closed in 1979 and is now the East Moline Correctional Center. (Courtesy of John Wetzel.)

Coal Valley can perhaps lay claim to helping future lumber magnate Frederick Weyerhaeuser get his start in the lumber business. Weyerhaeuser had been hired to manage a branch lumberyard recently opened in town. He built this house and settled in with his new wife. When the parent company in Rock Island failed, he and his brother-in-law Frederick Denkmann purchased the mill, thus beginning the Weyerhaeuser and Denkmann Lumber Company.

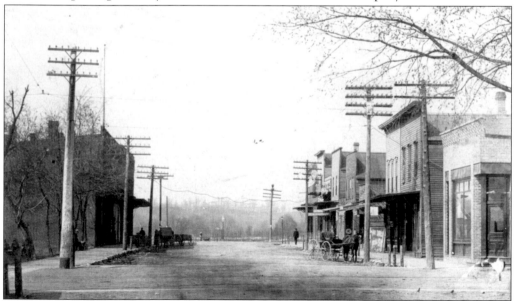

While many structures from a town's early years have been replaced with new buildings, roads, or parking lots, Milan can boast that almost all of what is seen here, looking north from West Second Avenue along West Fourth Street in about 1910, is still standing. The occupancy has changed many times since, but the real estate has remained largely intact.

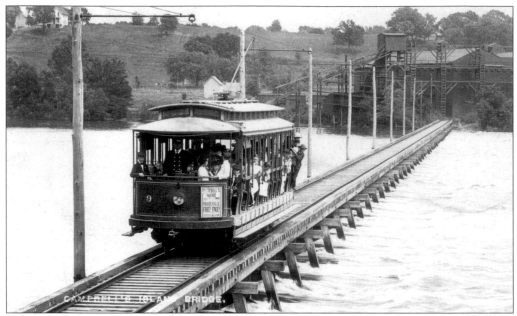

Like Black Hawk's Watch Tower and Prospect Park, Campbell's Island was purchased by the streetcar company for the purpose of building an amusement park that would cover the entire island. The first streetcar bridge to the island was constructed in 1904 atop an old closing dam that had been built by the U.S. Army Corps of Engineers in 1899. The complex in the background is the Moline Ice and Coal Company.

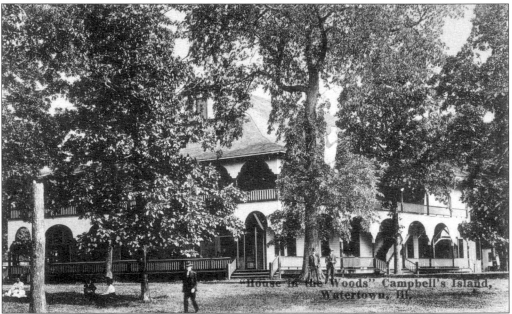

Built in 1904 as part of the Mississippi Valley Traction Railroad's development of Campbell's Island, the House-in-the-Woods offered dining on the first floor and orchestra concerts in the ballroom on the second floor. Those who maintained summer cottages on the island made frequent use of the inn. It was totally destroyed by fire in September 1911, after several smaller ones that summer. Construction on a replacement was completed the following spring.

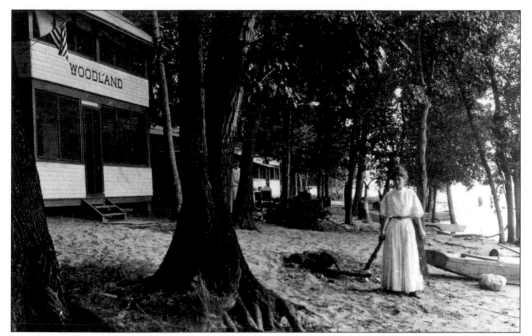

A young woman enjoys the shade and cool summer breezes off the river on the north shore of Campbell's Island around 1919. Cottages were available for rent, and some of the more affluent built their own summer cabins. Extra streetcars were added on the island's service in the mornings and afternoons so seasonal residents could get to and from work in the cities.

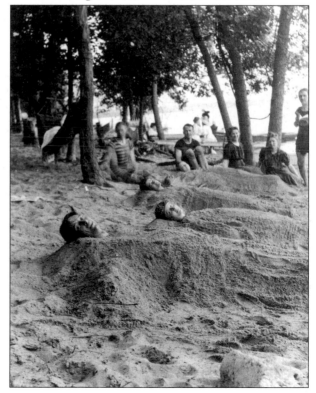

The north shore of Campbell's Island had the largest and sandiest beach because of its exposure to the main channel of the river. High water and flooding always washed sand downriver from north of Cordova, an area that was rich in deposits of sand and gravel. These young people appear to be enjoying an afternoon of swimming and burying each other on the beach.

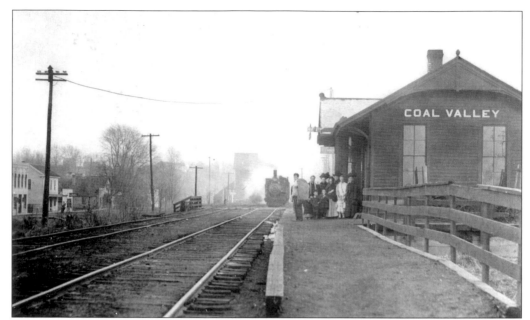

Coal Valley's first train depot was destroyed by fire and replaced with the building seen in this photograph taken prior to 1910. The second depot was destroyed by fire in 1910, and another new depot was built on the same foundation. That third depot remained until the railroad discontinued operations in Coal Valley in 1940 and was then torn down. (Courtesy of Coal Valley Library.)

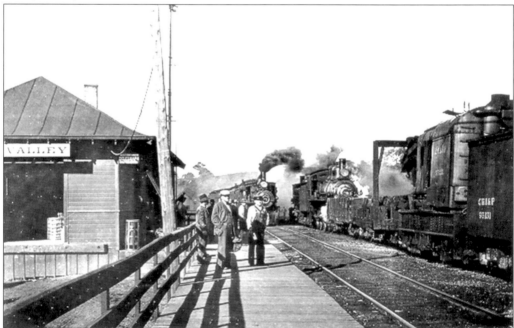

When the first trains of the Rock Island Railroad came to Coal Valley, they turned around because trackage ended there. When the line was later extended to Orion, trains had trouble making the grade east of town and were either split, or, as this 1915 photograph seems to illustrate, they were pushed with a helper engine. (Courtesy of the Coal Valley Library.)

Typical of the many one-room schoolhouses found throughout the early years of the county, Coe Township's Bluff School opened in 1856, one year before the township was formed. It sat at this site for nine years, but it was later moved to other donated farmland and had a basement added. Due to dwindling enrollment, the school was vacated in 1947, when a new consolidated school took its place.

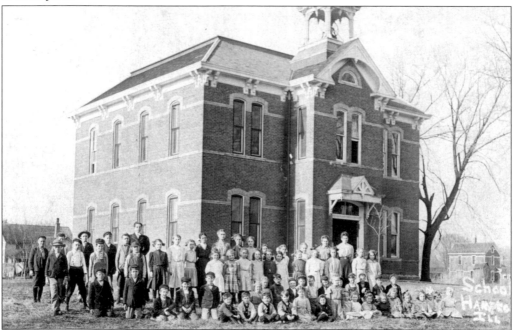

The students of the Hampton School pose for this group photograph around 1920. The school was constructed in 1880, and it still exists today, as the new grade school was built encircling the old building. It is said that many of the early village inhabitants were drawn to Hampton because of its fine schoolhouse, curriculum, and educators. (Courtesy of Beverly Coder.)

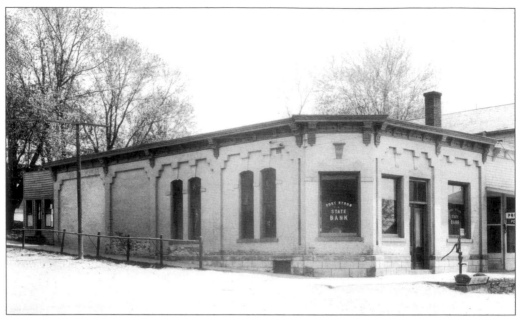

W. H. Devore established a general store and bank in the 1850s. The banking business outgrew the safe in the general store, and in 1863, Devore established the W. H. Devore Bank. That bank was converted to a state bank and incorporated under a new name, the Port Byron State Bank, in 1903. This photograph by commercial photographer H. K. Williams was taken around 1920. Note the water pump and horse trough.

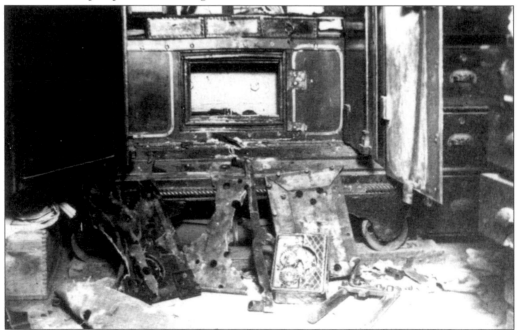

Old television Westerns never got it quite right. In those programs, a safe was blown, the door flew open, and the bandits easily scooped up the loot and made their escape. In this late 1920s photograph, the results of a real safe robbery at the Port Byron State Bank show parts of the safe and its contents heavily charred and damaged. What was the condition of the money?

Lifelong Edgington farmer John Eckhardt was a member of the county's agricultural league, which was entrusted to select a county farm advisor. This photograph from 1917 reveals a gathering at Eckhardt's farm, possibly to poll area farmers as to who might be a qualified candidate. Note that the men are all seated under the trees, while the women are seated near the house, evidently without any input.

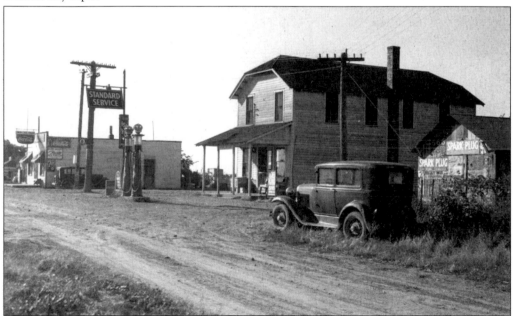

The largest township in the county by area, Drury Township has only one town, Illinois City, but only half of it is in that township. The other half is in Buffalo Prairie Township. Regardless of size, every town needs a grocery store, gas station, and post office. In this photograph from about 1930, all three are seen along Illinois City's main street: the grocery is on the left, and the post office is inside the gas station.

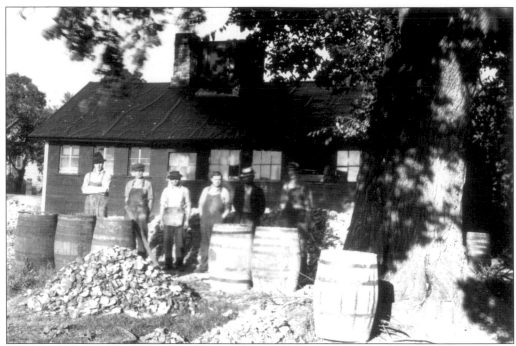

Because of its location on the Mississippi River, Andalusia was considered the best ferry site north of St. Louis in the mid-1800s. Many of Iowa's settlers crossed here. The Andalusia area was rich with tillable soil, coal, limestone, and potter's clay. In addition to waterpower for its saw- and gristmills, the river provided an abundance of clamshells for button manufacturing. The Heinze Button Factory was a busy place in 1904.

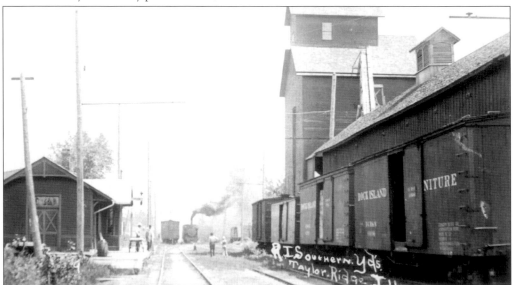

The Rock Island Southern Railway connected Rock Island with Monmouth, although it was not part of the Chicago, Rock Island, and Pacific Railroad (CRI&P). It did use the CRI&P's track rights though. Steam locomotives hauled freight, but the line was also electrified for interurban passenger service. A branch line to Aledo ran through Taylor Ridge and Reynolds. The last run on the line occurred in 1952. (Courtesy of Sam Hutchinson.)

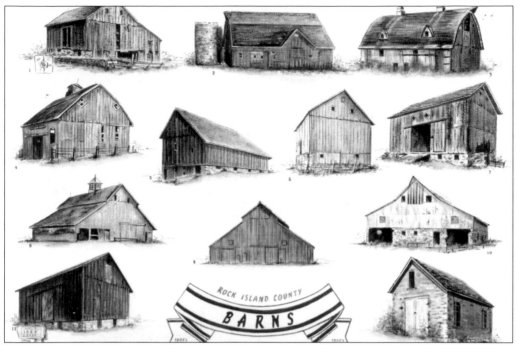

Before they disappeared for good, the county historical society cataloged the unique architectural styles of old barns from around the county. From left to right in the photograph above, the owners and their locations are (top row) Lannoo brothers farm, Coe Township; Joseph Schuch farm, Blackhawk Township; and the Charles Bowlby farm, Blackhawk Township; (second row) William Layer farm, Blackhawk Township; Dickhut family farm, Zuma Township; Darrel and Donna Free farm, Canoe Creek Township; and Harley Stropes farm, Buffalo Prairie Township; (third row) Marvin Lincoln farm, Drury Township; Lowell Titterington farm, Edgington Township; and Phyllis Danner farm, Buffalo Prairie Township; (bottom row) Mary Woodburn farm, Coe Township; and Mrs. Charles Shurts farm, Port Byron Township. The society has also cataloged the county's 50 centennial and sesquicentennial farms.

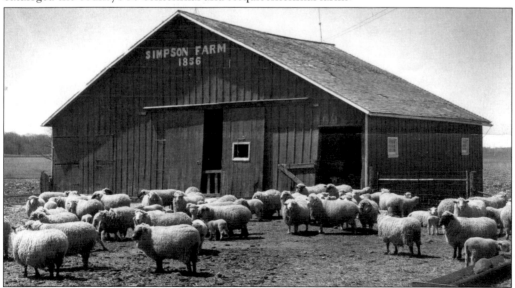

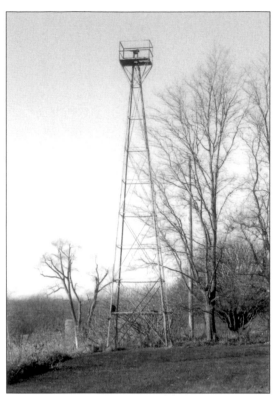

To allow pilots to safely fly mail at night, the Department of Commerce began building a network of airway beacons in 1926 to guide pilots to their airport destinations. Towers were erected every 15 to 25 miles apart, and the beacons could be seen for 40 miles in clear weather. One of those beacon towers still stands along old Route 2 between Rapids City and Hillsdale.

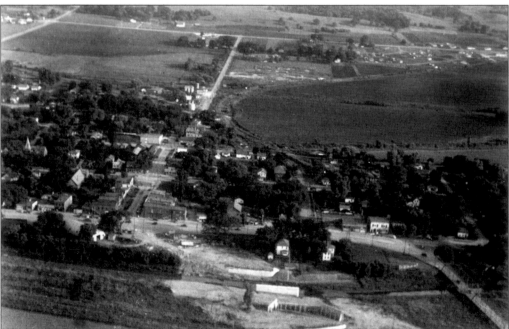

This aerial photograph, taken by Ken Brostrom, shows Milan as it was in 1946. Route 67 is on the extreme left, West Fourth Street is near the center, and Andalusia Road can be seen near the top. The Milan Oil Company and its storage tanks can clearly be seen near the center of the photograph. Notice also the railroad snaking through town toward Andalusia Road.

Two

THE URBAN HISTORY

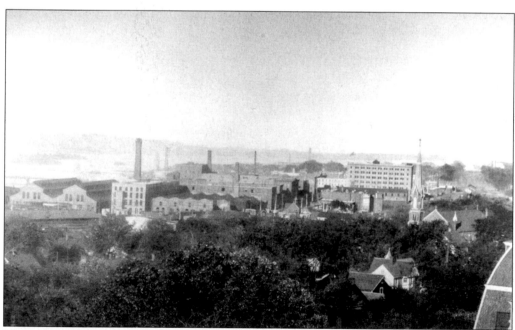

The smokestacks alone tell the tale of how industry was thriving along the river around 1900. While this happens to be an overview of Moline's factory district, it could be a depiction of any of the larger cities in Rock Island County. Drawn to the river in the mid-1800s by abundant waterpower, a wide variety of industry helped create this mosaic of brick and mortar. (Courtesy of Stan Leach.)

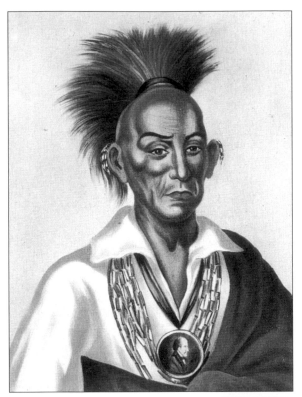

The Sauk Indian warrior Black Hawk is probably the county's most recognized individual in both history and name. He and his people lived in the village of Saukenuk, the area between the confluence of the Rock and Mississippi Rivers. Claiming the government stole Native American land, he tried to stop the white settlements with years of skirmishes. Although defeated in battle, his influence helped fashion Rock Island County history.

Much of the county's recorded history would not be available if it were not for John Hauberg. A lawyer, business executive, writer, photographer, and historian, Hauberg is responsible for many of the photographs in this book. He recorded oral histories of the old settlers and pioneers of the county, and his deep interest in the Native Americans of the region culminated in the creation of the Black Hawk State Historical Site.

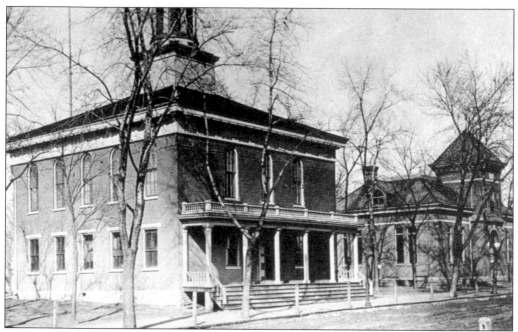

By 1838, Rock Island County had built its first courthouse, shown here on the left. It was located on the block of ground where the present courthouse stands. In addition to serving the needs of the county judicial system, the building also served as a civic and social center, and on Sundays, it was used as a church. The building to the right of the courthouse was the clerk's office.

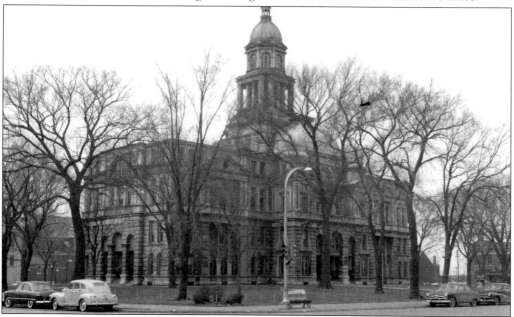

As the county grew, it became evident that improvements and additions to its first courthouse were needed. In 1893, a committee was formed to investigate construction costs and whether the citizens would bear the cost of a new building. Through an 1894 referendum, permission was given to issue bonds to cover the cost of the new courthouse. Ground was broken in 1895, and this structure was dedicated in 1897.

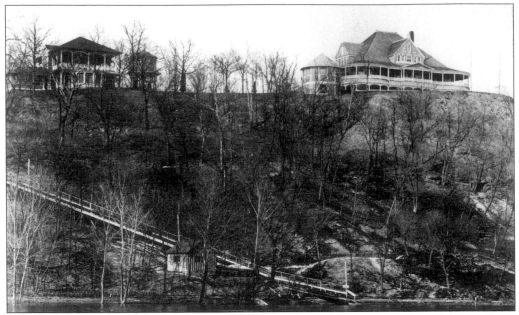

Black Hawk's Watch Tower, high on the bluff overlooking the Rock River, was developed as a resort by Bailey Davenport in 1892. Its chief merits were its view, picnic areas, and springwaters. After Davenport's death, the property was purchased by the Rock Island and Davenport Railway Company and developed into an amusement park to increase streetcar ridership in the evenings and on Sundays.

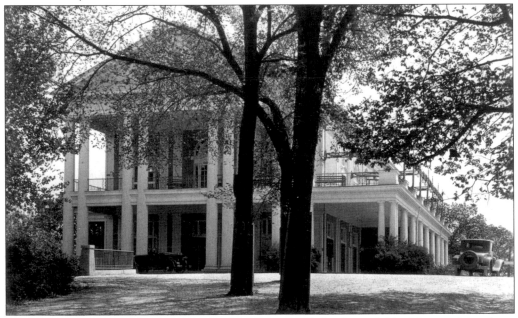

When the Watch Tower inn was destroyed by fire in 1915, this beautiful building took its place. Built in record time by contractor Henry Horst, construction began in April 1916 and was finished in mid-June of that year in time for the Fort Armstrong centennial celebration. The first floor contained public and private dining rooms and a kitchen, and a grand ballroom was located on the second floor.

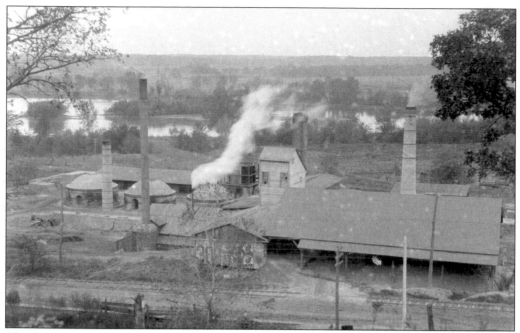

The Sears Brickyard in Searstown, now in west Rock Island on the Rock River, was just one of the many enterprises of David Sears. He created a power dam off the Moline shore in 1837. By 1868, he had built several dams, several mills, a cotton factory, and this brickyard on the Rock River between modern-day Rock Island and Milan.

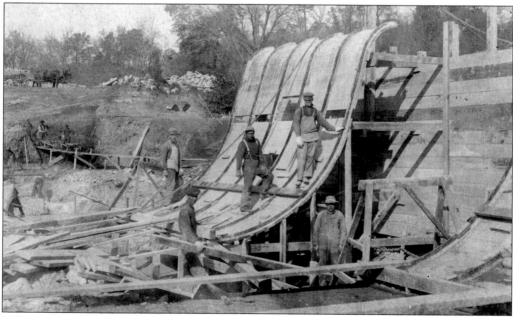

Following up on what Sears had started with dam building for power generation on the Rock River between Rock Island and Milan, Samuel Davis received permission from Congress to build a dam to feed water to his proposed new powerhouse. Construction began on the dam in 1907, and by 1912, it and the powerhouse were completed. Viewed looking west, this photograph shows that the workers have begun spillway erection.

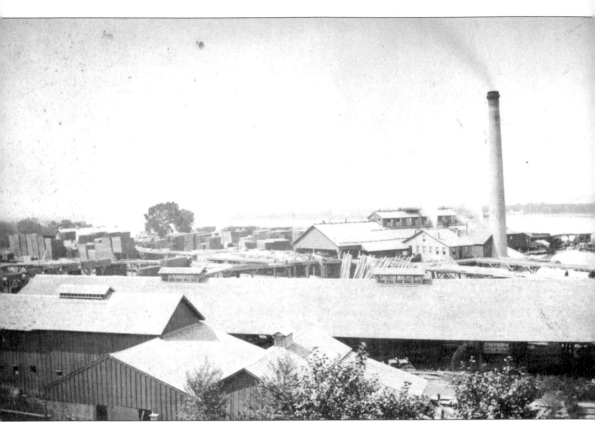

With the purchase of a failed lumber mill in 1860, Frederick Weyerhaeuser and Frederick Denkmann began a business that today is an international giant in the forest products business and has operations in 18 countries. As a former lumberyard manager, Weyerhaeuser was trained in the handling of lumber, while Denkmann, a skilled machinist, handled the manufacturing end of the business. Through mergers and acquisitions, the duo continued their unprecedented growth, and a number of subsidiary companies were formed. In 1864, the company purchased its first forests in Wisconsin and began rafting millions of board feet of lumber down the Mississippi River. As the business continued to flourish, retail outlets were added and more forestland was purchased in Michigan, Minnesota, Idaho, Oregon, and Washington. In 1900, the company and its partners made the largest private land purchase at the time—over one million acres of forests in Washington State. Denkmann died in 1905, and Weyerhaeuser died in 1914. Both are buried in Rock Island, not far from the mill pictured here.

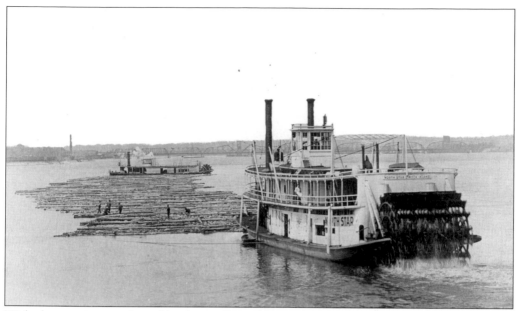

With the growing number of lumber mills in the county came the ever-growing need for raw materials. That need was satisfied in the forests of Wisconsin and Minnesota. Log rafts pushed by boats got the logs to the mills. The steamer *North Star*, aided by a bow boat to help steer the raft, heads toward one of the holding pens at the Weyerhaeuser and Denkmann Lumber Company.

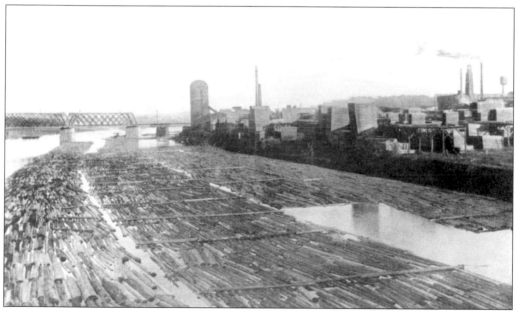

Logs rafts brought down from the Wisconsin and Minnesota timberlands were stored in pens along the riverbanks until the logs could be separated for cutting. These log pens, called booms, were alongside the Weyerhaeuser and Denkmann Lumber Company at First Avenue and Fourth Street in Rock Island. The Crescent railroad bridge is seen the background.

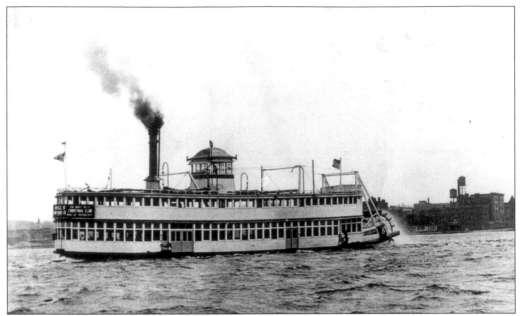

Originally built by the Kahlke Brothers Boatyard in 1904 as the *Davenport*, it was purchased by William J. Quinlan in 1924 and renamed the *W. J. Quinlan*. Reworked by the Kahlkes, it returned to the river as an excursion ferry between Rock Island and Davenport. The boat featured a band, a dance floor, a bar, and slot machines. Passengers could ride all day for a nickel. It was deemed unseaworthy in 1946.

Master pilot Hannas Witt had captained the *W. J. Quinlan* ferry for 15 years on its trips between Rock Island and Davenport. While making a river crossing in 1942, Witt suffered a heart attack and died at the wheel as the boat reached midstream. At the time of Witt's death, he was one of the oldest pilots on the Mississippi River. (Courtesy of Dennis Witt.)

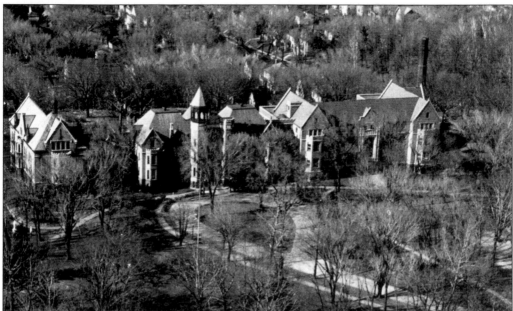

The Sisters of Visitation opened an academy in Rock Island in 1899. Due to increased enrollment, the Sisters acquired land and began building this beautiful complex in 1901. The original school and convent were located in the building on the left. Added later, the building on the right contained rooms for boarding students, a chapel, a library, and classrooms. Closed in 1978, the complex was gutted by fire in 2005.

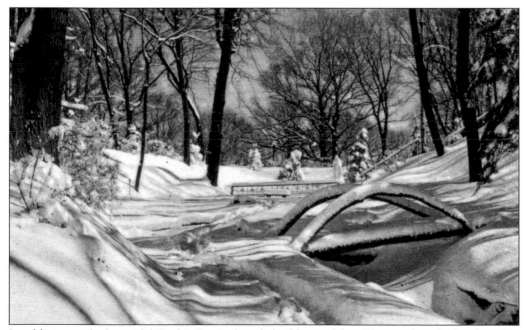

In addition to the beautiful Gothic Revival–style buildings of the villa complex, the landscaping of its grounds was not forgotten. This winterscape captures the serenity of the contemplative garden on the west side of the property. A statue of the Madonna and a prayer railing and bench are visible in the right center of this photograph. (Courtesy of John Wetzel.)

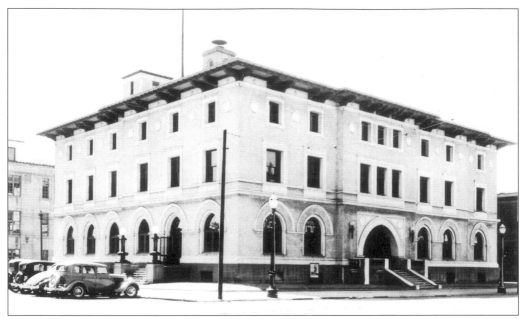

Several small buildings served as Rock Island's post office until this structure was built in 1896 on the southwest corner of Second Avenue and Sixteenth Street. Originally built with two and a half stories, the building was expanded in 1914. A new federal courthouse and post office complex was built on the site of Spencer Square in 1956, and this land became a parking lot. (Courtesy of John Wetzel.)

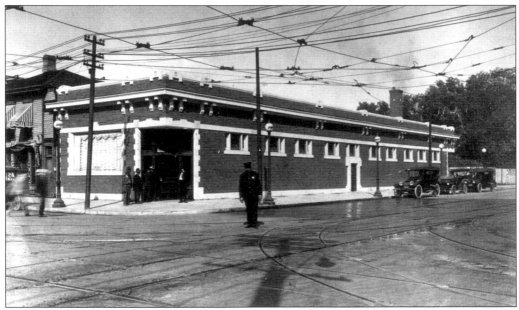

Owner Anthony Billburg called his saloon, the New Billburg, the "longest bar in the world." Located on the northeast corner of Twentieth Street and Third Avenue in Rock Island, it did indeed have a long bar—117 feet long. Supposedly, a channel of running water at the base of the bar served as a self-cleaning spittoon. Opened in 1915, it was closed by World War I, Prohibition, and a prison sentence.

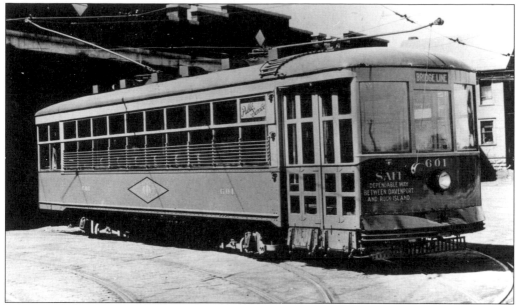

Electrified streetcars first appeared in the county in late 1889. The Bridge Line, operating from Rock Island to Davenport across the Arsenal Bridge, received electrical power in 1894. This Bridge Line trolley is shown leaving the carbarn on Rock Island's Fifth Avenue near Thirty-fifth Street. April 15, 1940, was the last day of streetcars like this on the Bridge Line, replaced by newly purchased buses the next day.

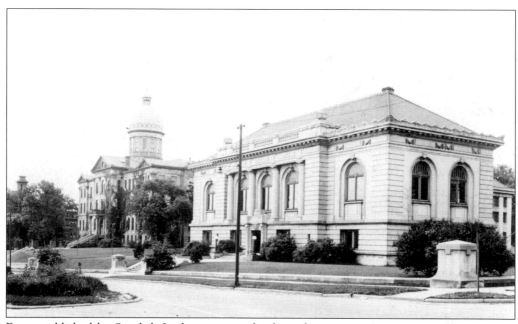

First established by Swedish Lutherans as a theological seminary, Augustana College opened in Chicago in 1860. It moved to Paxton three years later. When it was felt that Paxton was not serving the needs of the college, it was moved to Rock Island in 1875. This 1920s photograph shows the main classroom building called Old Main on the left and the Denkmann library building on the right. (Courtesy of John Wetzel.)

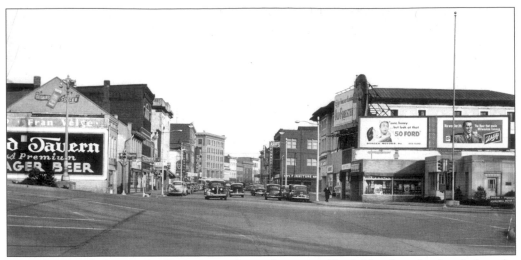

This photograph from 1950 illustrates a vibrant downtown Rock Island in the days before the large retail malls. Taverns, nightclubs, and grocery, furniture, department, and clothing stores are all in view looking east on Second Avenue from Fifteenth Street at the foot of the Centennial Bridge. Parking looks like it might be a problem, and it is hard to miss the message that Old Style was a premium lager beer.

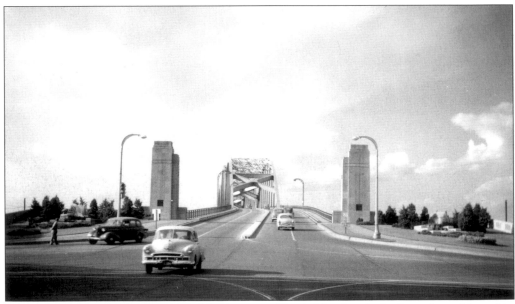

Opened in July 1940, the Centennial Bridge united Rock Island with the Iowa shore. Named in honor of the city's 100th anniversary, the bridge was the first tied-arch and first four-lane bridge across the Mississippi River. This photograph was taken in 1952 after buildings were demolished and new approaches, fountains, and landscaped gardens had been added, giving a smoother transition to the gracefulness of the bridge's five arches. (Courtesy of John Wetzel.)

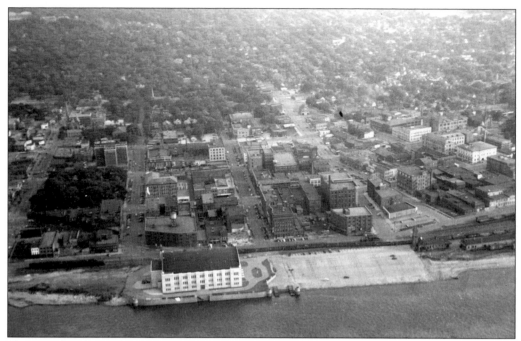

Photographer Ken Brostrom snapped this aerial view of downtown Rock Island, looking south. Prominent on the riverbank, from left to right, are the National Guard armory, the old ferry landing, the levee parking lot, and the Milwaukee Railroad's depot, freight warehouse, and train yard. The photograph is pre-1950, as the WHBF television tower is not yet seen rising above Third Avenue.

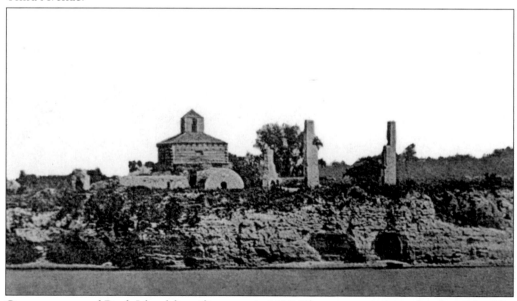

Congress reserved Rock Island for military use in 1809. The two westernmost battles of the War of 1812, fought near Rock Island, forced the military to build a fort on the western end of the island in 1816. Its presence provided protection for settlers and attempted to monitor Native American tribal feuds. The military abandoned the fort in 1845, and it partially burned in 1855, as this 1859 photograph reveals.

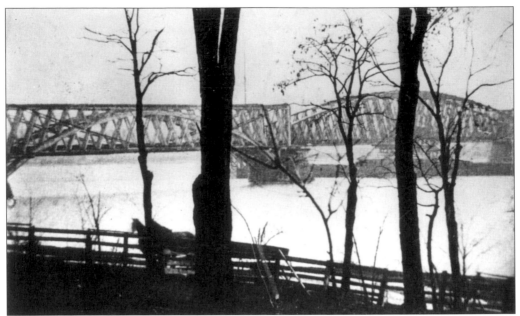

Having reached Rock Island in 1854, the railroad needed a bridge across the Mississippi River to advance farther west. Work started on this, the first railroad bridge to cross the river, in 1853. Opposition on the part of steamboat and ferry companies was high, but the bridge was completed in 1856. Two weeks after completion, it was struck by the first of many steamboats and rafts.

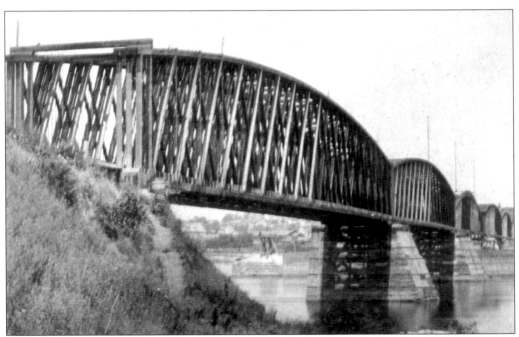

Years of strikes by steamboats, increased use by trains, and the larger weight of the trains all took their toll on the first bridge. Arched top suspension cords were added around 1860, and new spans were built atop the existing piers in 1866 to strengthen and further the life of the bridge. This view of the revised bridge looks southeast from the Iowa side toward Rock Island.

46

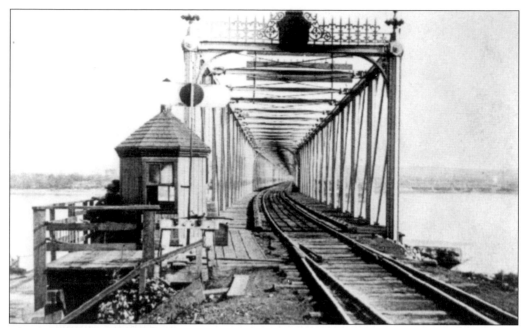

The third railroad bridge built from Arsenal Island to Iowa was constructed in 1872. A locomotive engineer had this view heading toward Illinois. Originally trains were to cross on the lower deck. When it was realized that wagons with people would be crossing on the top deck and be subject to locomotive smoke and soot, deck usage was reversed. The current Government Bridge replaced this bridge in 1896.

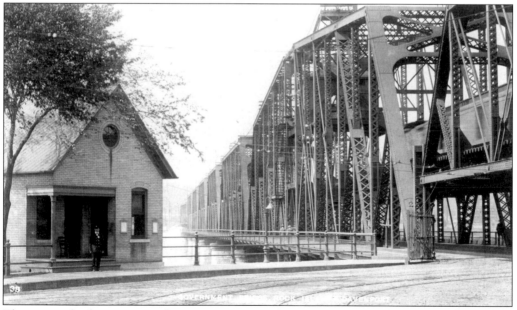

The current bridge spanning the Mississippi River from Arsenal Island to Iowa is this imposing structure. It opened in 1896 and has remained essentially the same as when it was built. This first span rises by compressed air to allow it to swing open for the passage of boats underneath. Originally co-owned by the railroad and the government, ownership deferred to the government when the Rock Island Railroad went out of business in 1980.

In mid-1863, 12 acres of swampy land on the north side of Rock Island were set aside for use as a Union Civil War prison. The complex was not yet finished when the first 468 prisoners, captured in Tennessee, were moved there that December. More than 5,000 additional prisoners were added before the end of the month. With that many men incarcerated in one place, sanitary conditions became deplorable, and disease quickly spread, including a smallpox epidemic. Hundreds died in the first few months alone. During the spring of 1864, the hospital depicted in this photograph was built, and sanitary sewers were installed. Health conditions were greatly improved after that. However, in response to the way Union soldiers were treated at the Confederate prison at Andersonville, rations were cut at Rock Island and more deaths resulted from malnutrition. The prison was destroyed after the close of the war, and the Rock Island Confederate Cemetery holds the graves of nearly 2,000 prisoners who died during their stay at the prison.

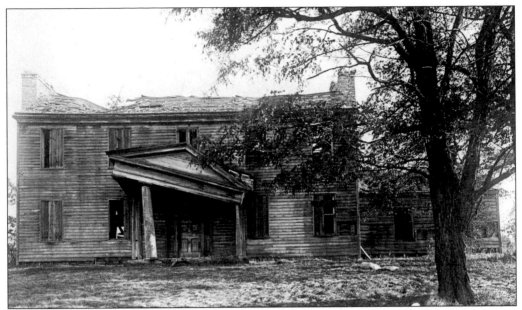

This was the home of Col. George Davenport, the first white man to make a permanent settlement in today's Rock Island County. Davenport was a fur trader and army provisioner, and because he was trusted, he was also a mediator between the Native Americans and the government. He built this house in 1833 and lived here until his death in 1845. Time, vandals, and souvenir hunters left the house in this condition.

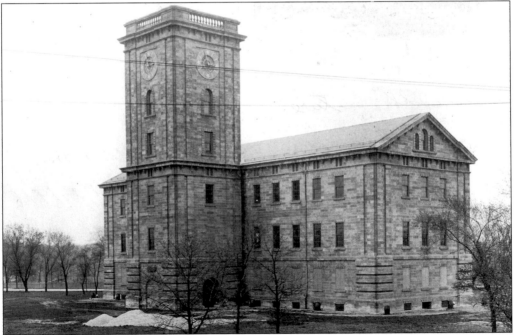

First commanding officer of the arsenal, Maj. Charles Kingsbury located and designed the first three buildings to be built. The first and only building to be completed under Kingsbury was this storehouse, finished in 1867. It is known today as the Clock Tower building and is home to the U.S. Army Corps of Engineers.

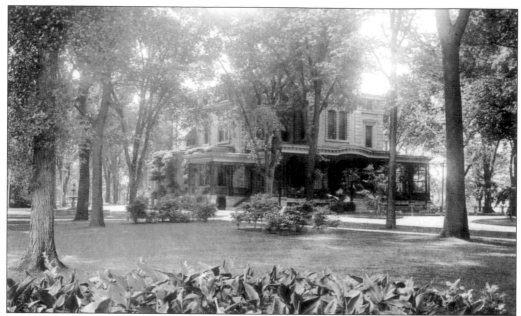

Constructed during 1870 and 1871 as the residence for the second commandant of the Rock Island Arsenal, this beautiful home is known as Quarters One. Designed by Gen. Thomas Rodman, its size symbolized the arsenal's place and importance as a government installation. With 51 rooms and 22,000 square feet, this particular building has the distinction of being the second-largest government residence after the White House.

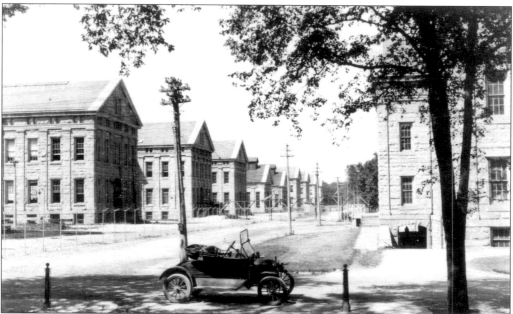

A row of shops was built as part of Rodman's grand plan for the Rock Island Arsenal. Rodman did not live to see the construction started, but third commandant Lt. Col. Daniel Flagler had the shops built between 1871 and 1886 to Rodman's plans. Those shops formed the core of the arsenal's manufacturing facilities, and more were added later with the same architecture. (Courtesy of John Wetzel.)

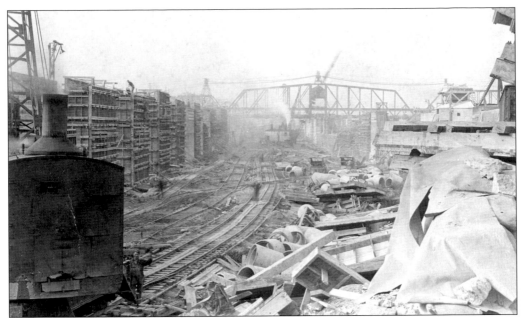

When the system of 29 locks and dams on the Mississippi River was approved, lock and dam 15 was the first to be built to submerge the dangerous Rock Island Rapids. Begun in 1931, construction took three years to complete. The lock and dam's location, at the west end of Arsenal Island, was chosen because the river was narrowest at that point. (Courtesy of U.S. Army Corps of Engineers.)

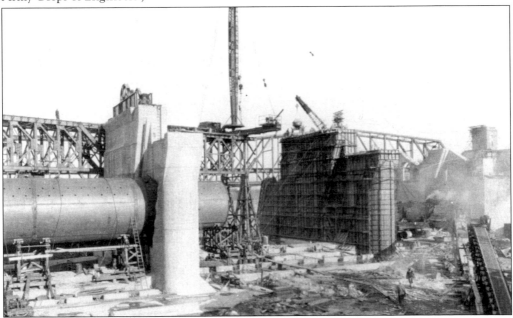

The men in the lower right of this photograph give an idea of the immense proportions of the roller dam. Submersible gates could not be used, as the river was too shallow. Since the gates had to be lifted out of the water during floods, roller gates were used instead. Their use also allowed silt and debris to pass under them during periods of normal water levels. (Courtesy of U.S. Army Corps of Engineers.)

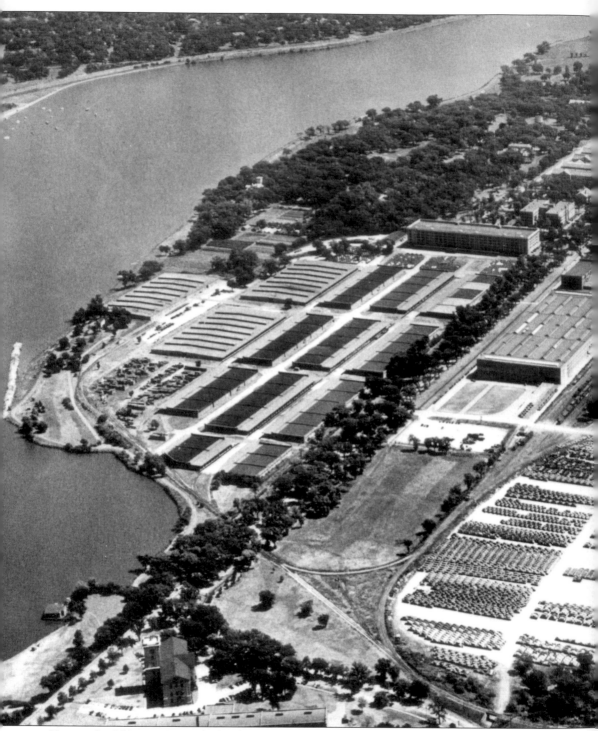

Here is the 950-acre Arsenal Island, as it looked in the early 1940s. This photograph, looking east and slightly north, shows the immensity of the military presence on the island. Warehouses and storage lots can be seen in the lower left, lower center, and center right. The Kingsbury Manufacturing Center and the former arsenal shops appear in the center and upper center.

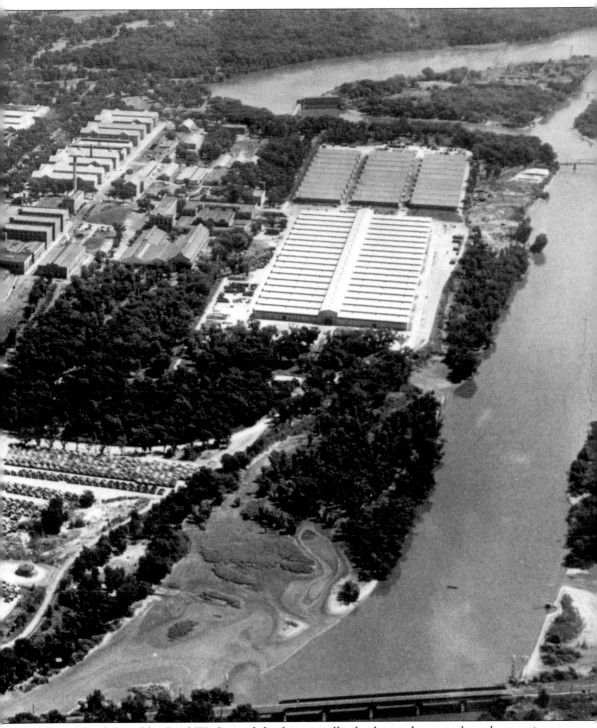

Sylvan Island, Republic Steel Works, and the former trolley bridge to the arsenal can be seen in the upper right. The national and Confederate cemeteries, as well as a golf course, are located on the upper end.

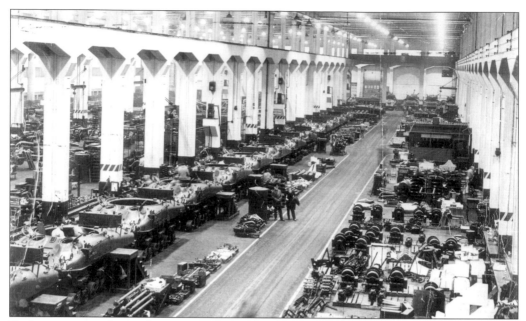

Tanks were manufactured or remanufactured at the arsenal before, during, and after World War II. This photograph shows a version of the M4 Medium Duty tank. Tanks were also built at the former J. I. Case Company plant in Bettendorf, Iowa. During the war years, the arsenal employed more than 18,000 people. That was in addition to the employees of the implement manufacturers who were also turning out defense materials.

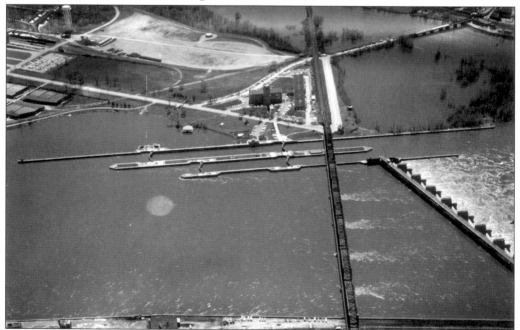

This mid-1960s aerial photograph gives an excellent overall view of lock and dam 15's orientation on the river at Rock Island. The 600-foot-long main lock is closest to the guide wall. The smaller auxiliary lock is used mainly for pleasure boats. The angled roller dam, on the right, is the largest in the world. The Clock Tower building is clearly seen in the upper center.

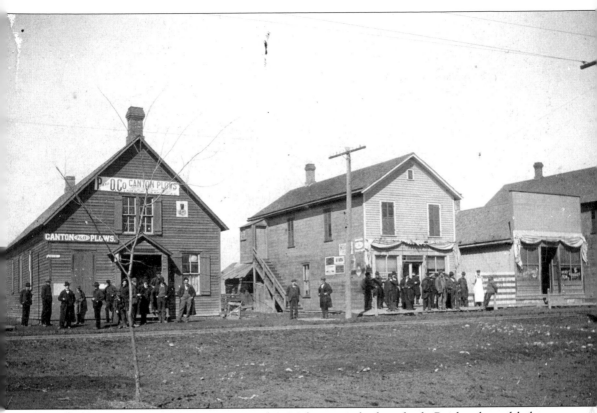

Few of today's younger residents are aware that Moline once had a suburb. Bordered roughly by today's Avenue of the Cities on the north, Fourteenth Street on the west, Twenty-sixth Avenue on the south, and Eighteenth Street A on the east, Dr. Jacob Stewart created Stewartville in the rural area a quarter mile from the southern limits of Moline. In existence from 1871 to 1896, Stewart's development was aimed toward people of modest means. Many of the workers employed in the mills and implement factories downtown were able to afford homes built here. Stewartville had its own school, town hall, post office, and businesses. This photograph from the late 1800s shows several of the businesses that were located on today's Sixteenth Street. The building on the left was the town hall, which shared space with the Glenn and Trevor Hardware Store. The next building was a butcher shop, and the building on the extreme right was a dry goods store that is the main portion of Teske's Pet and Garden Center today.

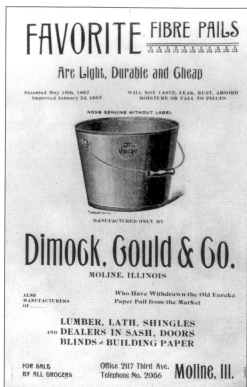

Dimock, Gould and Company created a line of fiber pails to enhance its woodenware product line. They were warranted not to leak. The firm manufactured and marketed the pails between 1882 and 1899, although it had sold its woodenware line to a syndicate in 1890 to concentrate on pails and lumber building products. When a portion of the manufacturing facility burned in 1899, the company ended its pail production.

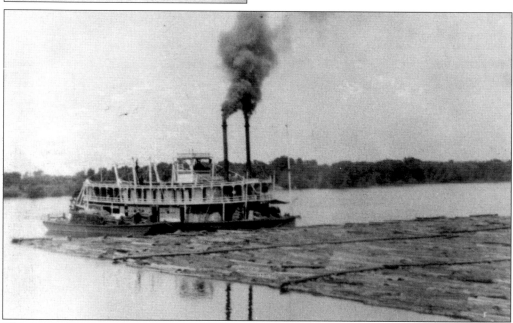

The Weyerhaeuser and Denkmann Lumber Company was not the only large lumber company in Rock Island County. This well-known raft boat, *Moline*, belonged to Dimock, Gould and Company. It was built in 1880 and used until 1899, when the firm discontinued its sawmill operations. After its sale, the *Moline* was used for Missouri River excursions. It was later renamed the *Emerson* and pushed a showboat. It overturned and sank in 1908.

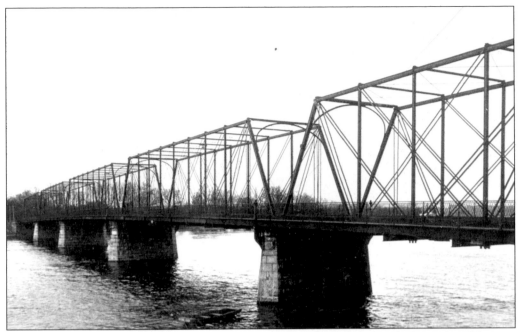

The first bridge from Moline to Arsenal Island was actually atop a dam built in 1837. The city built a wooden bridge in 1860, but it was destroyed by river ice during the winter of 1867. In its place, this iron bridge was erected in 1873 at the foot of Fifteenth Street and was used until 1932 when a new concrete bridge was erected. (Courtesy of John Wetzel.)

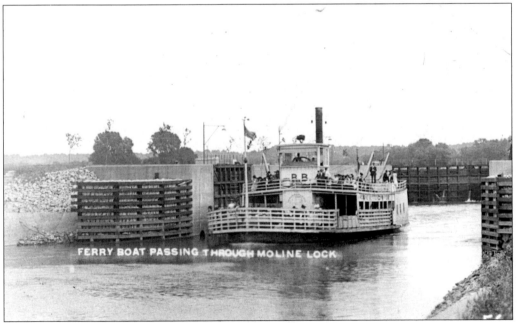

FERRY BOAT PASSING THROUGH MOLINE LOCK

Prior to construction of the lock and dam system in the 1930s, another lock had been built in 1907 to allow steamers better access to the Moline harbor area and to better navigate the waters of the Rock Island Rapids. The Moline Lock, at the northeast tip of Arsenal Island, was part of a lateral dam that had been created to flow water to the lock. (Courtesy of John Wetzel.)

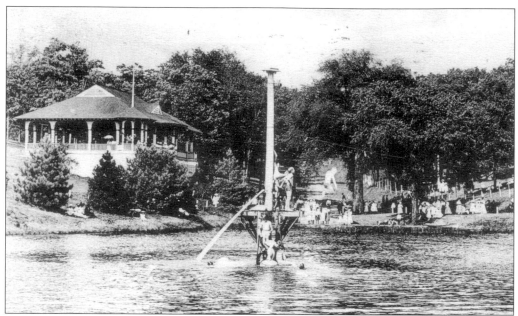

Owned by the Tri-City Railway Company, Prospect Park in Moline offered concessions, a pavilion for concerts, fountains, a lagoon for swimming and rowboats, and amusement rides. All this gave a reason to ride the streetcar. Eventually the city purchased the property for use by its park department. The lagoon was the city's swimming pool until the Works Progress Administration (WPA) built a real pool in the mid-1930s.

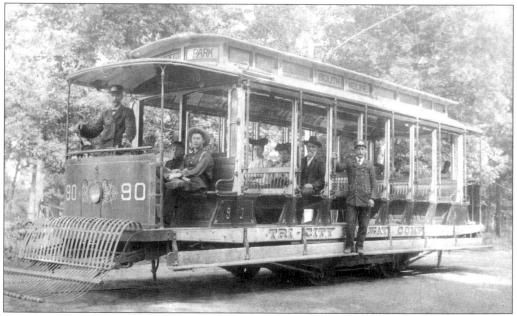

This photograph, taken in the very early 1900s, shows the first type of electrified trolley used on city streets. This particular car made trips on Moline's Prospect Park line. As this was an open trolley car, the ride could be hazardous. When loaded to capacity, passengers hung precariously along the side. At narrow rights-of-way, passengers had to get off to avoid being knocked off by fences or overhangs.

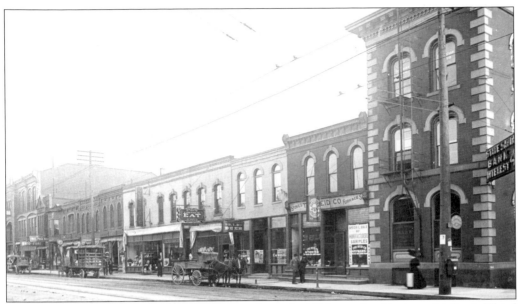

A little bit of everything could be found in the early 1900s on this block on Moline's Third Avenue, east from Fifteenth Street. From right to left are the People's Savings Bank, Reid Stove Company, the Casino tavern, the Presto Café, a clothing store, a hardware store, another tavern, and a 5 and 10¢ store. Many of these buildings remain today and are part of the area known as the John Deere Commons.

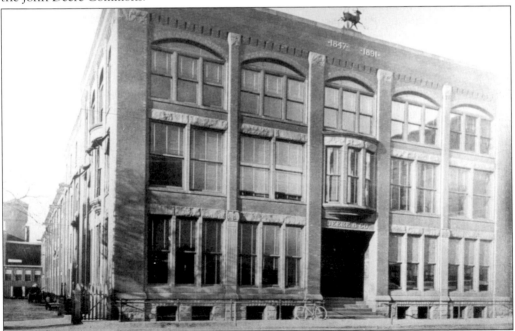

This photograph from about 1902 shows off Deere and Company's headquarters office at Third Avenue and Thirteenth Street in Moline. As Deere's worldwide business grew, so did its need for more employees and space. In 1964, a new Deere Administrative Center, designed by famed architect Eero Saarinen to express the company's agricultural roots, was built overlooking the rolling farmland of the Rock River Valley in southeast Moline. (Courtesy of Stan Leach.)

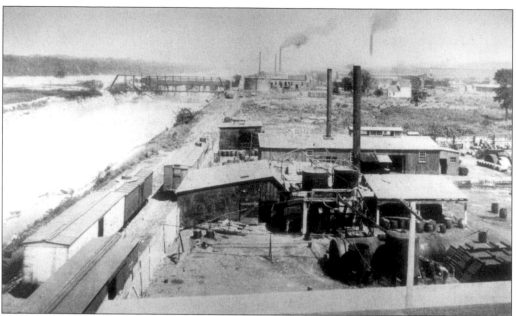

This photograph from about 1900 shows the Moline waterpower canal. This canal was created when a tip of Moline on Sylvan Slough was cut through to create a better head for the arsenal waterpower dam. Beyond the bridge, the dam of the Merchant's Electric Light Company can be seen, and the domed storage tank of the Moline Gas and Coke Company is to its right. (Courtesy of Stan Leach.)

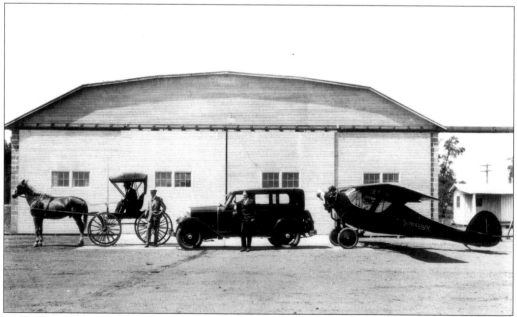

Willard Velie Sr. started the Velie Carriage Company in 1901. By 1908, it was evident that the automobile would replace carriages, and the company began manufacturing cars. Velie had developed a five-cylinder radial aircraft engine, and when Central States Aero Company began purchasing those engines, Velie bought the company and renamed it Mono Aircraft. The three stages of the Velie Motors Corporation came to a halt when Velie died in 1928.

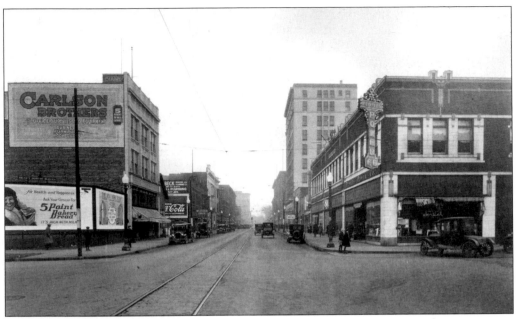

The General Electric Lamp Division used this 1925 photograph of downtown Moline to promote its line of stylish incandescent streetlamps that had recently been purchased by the city and installed by the People's Power Company. This view looks east on Fifth Avenue from Fourteenth Street. The People's Power retail store and offices are in the right foreground. The tall building on the right is the former First National Bank.

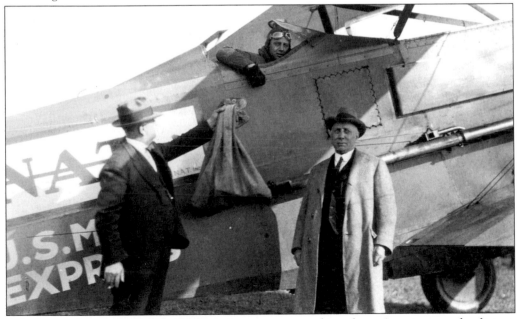

A little over four years after the Moline airport was created in a farmer's pasture south of town, National Air Transport (later to become United Airlines) made the first airmail flight into Moline from Chicago in May 1926. Moline postmaster George Carlson (left), accompanied by Rock Island postmaster Hugh McDonald, hands the unidentified pilot a bag of mail for the return flight to Chicago.

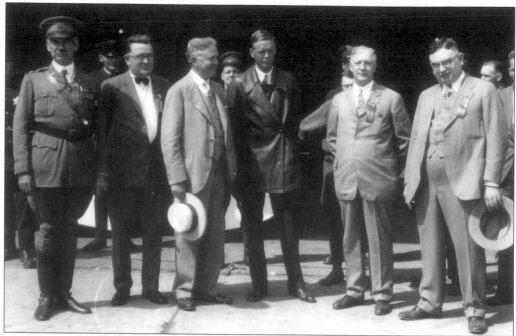

Just three months after his historic solo flight across the Atlantic Ocean, Col. Charles Lindbergh flew his *Spirit of St. Louis* into the Moline airport for a visit. Greeting him, from left to right, are Col. D. M. King, arsenal commandant; John Siefken, mayor of East Moline; Claude Sandstrom, mayor of Moline; Lindbergh; Louis Roddewig, mayor of Davenport, Iowa; and Chester Thompson, mayor of Rock Island.

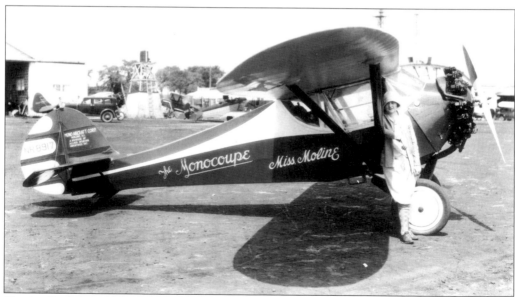

Phoebe Omlie raced and set flying records in her Velie Monocoupe. She was the first woman to earn a federal pilot's license and the first to receive an aircraft mechanic's license. She landed at the Moline Airport for fuel and a visit on her way to Cleveland during the 1929 Powder Puff Derby. She is posed next to the *Miss Moline*.

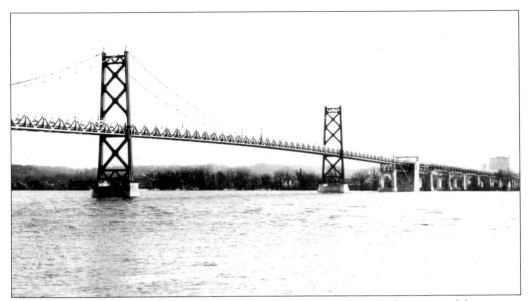

Until 1934, only one bridge crossed the Mississippi River in the metropolitan area of the county. That changed when construction was started on this span between Moline and Bettendorf, Iowa. Named the Illinois-Iowa Memorial Bridge to honor World War I veterans, it had an exact twin built just west of it in 1958. Interestingly, the Davenport Bridge Commission owned the bridge, and it did not touch that city. (Courtesy of Curt Roseman.)

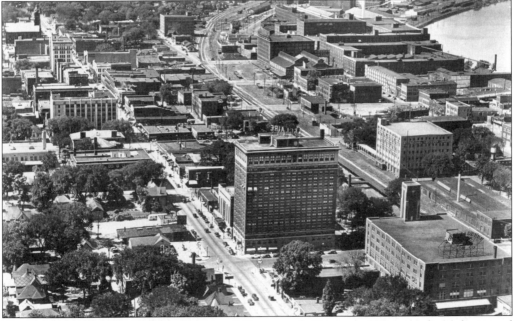

The various factories and warehouses of Deere and Company, Minneapolis-Moline, and International Harvester Company are easily seen along the riverfront in this 1940 aerial photograph of downtown Moline. Looking west from about Twentieth Street, the railroad tracks are clearly seen heading toward Rock Island. The building in the foreground with the tower is the Deere mixed-car warehouse. Just to the left of that tower is the covered concourse of the Rock Island train depot.

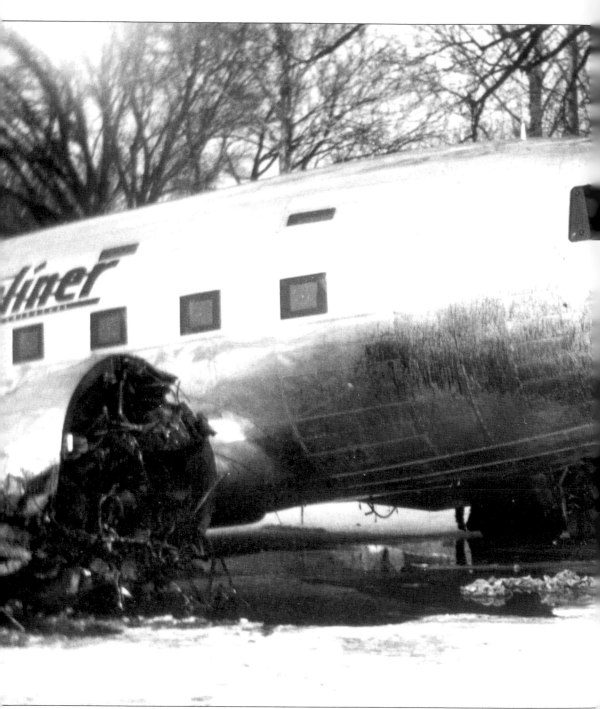

Personnel from United Airlines prepare to remove this DC-3 from the frozen Rock River just west of the Route 150 bridge, as curious onlookers watch. The plane developed problems with an engine over Iowa City during the early morning hours of January 12, 1940, and turned back to land at Moline. During a missed approach, the second engine lost power and the pilots made a forced landing on the frozen river. Flying on a westerly heading, the pilot somehow missed the bridge and dropped the plane on the ice with its wheels up. Sliding downriver, the plane's

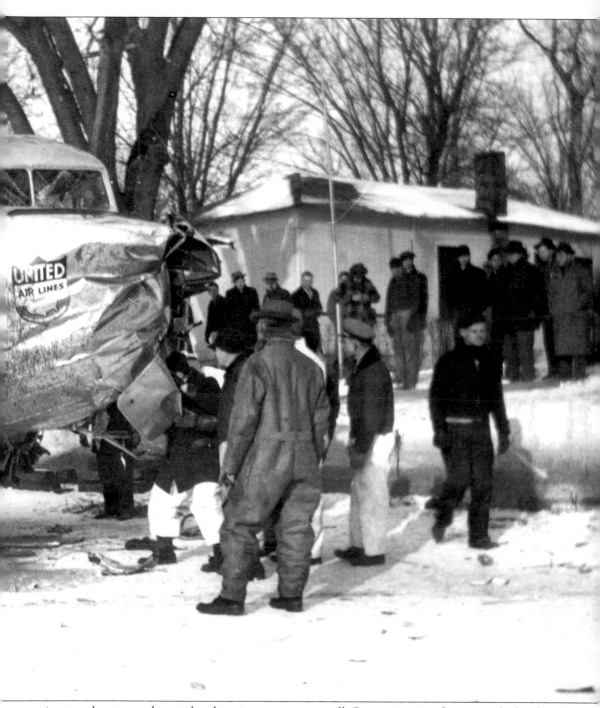

wing struck a tree and spun the plane into a concrete wall. One engine was thrown to the bank. While the fuselage was undamaged, the nose received the brunt of the collision with the wall. The pilots received bumps and bruises, but none of the passengers or the stewardess received any injuries. United mechanics removed the wings, loaded the plane on a trailer, and trucked the plane to the airline's repair facility in Cheyenne, Wyoming. (Courtesy of Buck Wendt.)

It has been said that at one time the Quad City area was second only to Detroit in the manufacturing of automobiles. Little is left that would remind people of that interesting and important contribution in Rock Island County's past history. The photograph above shows what is left of the foundation of the Velie carriage, automobile, and airplane factory. It is located on River Drive between Second and Third Streets in Moline. The bottom photograph shows the test track used for the Moline and Root and Vandervoort models at the former Root and Vandervoort Company manufacturing facility, located at the northwest corner of Seventh Street and Twelfth Avenue in East Moline. Hundreds pass these locations every day, most likely without a thought as to what these two sites are or what they might have been.

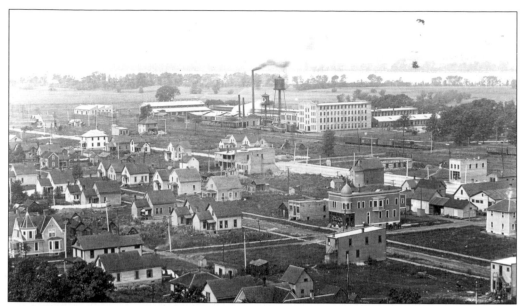

Taken around 1908, this photograph provides an excellent view of downtown East Moline and, in the upper center, the Root and Vandervoort engineering complex. Originally organized to manufacture stationary engines, it sold much of its product through Deere and Company. It later began building the Moline and Root and Vandervoort Knight model automobiles. The empty fields in the upper left of the photograph later became the site of the International Harvester East Moline Works plant.

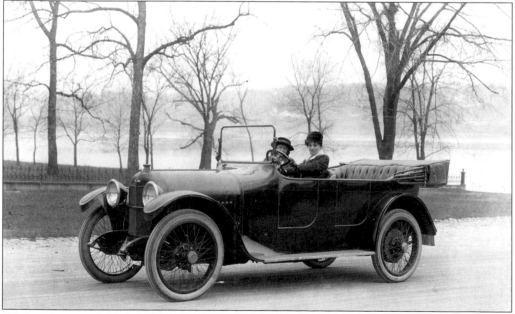

Of the 16 automobile manufacturers formed within a 50-mile radius of the Quad Cities, 9 were located in Rock Island County. The Moline was built from 1908 to 1918 and the Moline Knight was built from 1914 to 1921 at East Moline's Root and Vandervoort Company. It is not certain if this is an advertising photograph, but driver Hannah Norling and passenger Dora Ingwerson seem to enjoy their chilly outing in this 1915 Moline Knight.

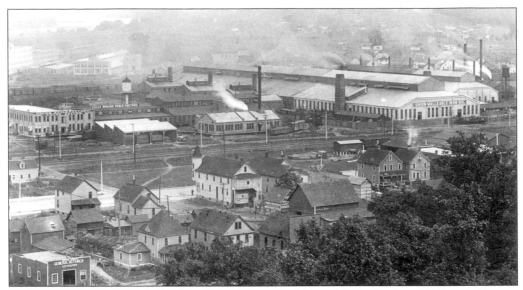

Looking northeast from the bluff in East Moline, the Union Malleable Iron Works can be seen on the right side of this 1910 photograph. Charles Deere, son of John Deere, organized the firm to supply castings to Deere and Company, which purchased it outright in 1911. It became known as John Deere Malleable Works in 1951. The two plants of the Moline Scale Company can be seen to its left.

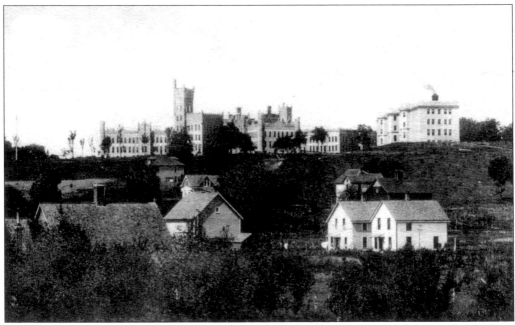

Built in 1898 as the Western Hospital for the Insane, this view shows the complex looking north from the former Watertown area of East Moline. It was later known as the Watertown State Hospital and then finally received the more appropriate name of East Moline Mental Health Center. The facility closed in 1979 and became the East Moline Correctional Center, a minimum-security prison. (Courtesy of John Wetzel.)

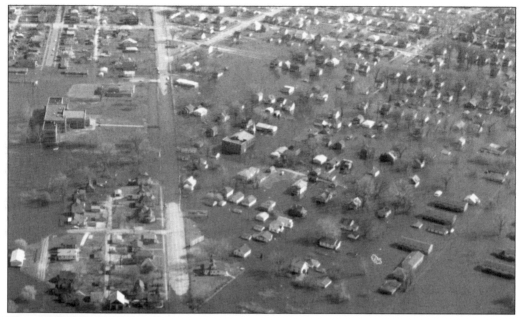

The northeastern portion of East Moline is known as Watertown, and in 1965, it certainly was. This photograph, looking south over Nineteenth Street in East Moline, shows that almost all the Watertown area was underwater by the time the Mississippi River flood crested at 22.5 feet. Hoffman Elementary School can clearly be seen in the left center, and Morton Drive has yet to be built.

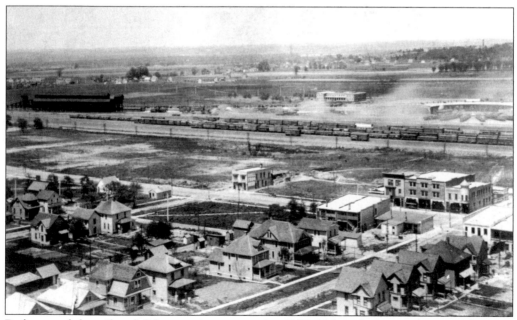

Built around the railroad, Silvis was incorporated in 1907. Although the population of the town was only a little above 300 at this point, more than 1,200 men were employed at the railroad shops. While Silvis had a shortage of housing for many years, it is apparent from this late-1920s photograph that many sturdy houses were built, and the business district was beginning to take shape along First Avenue.

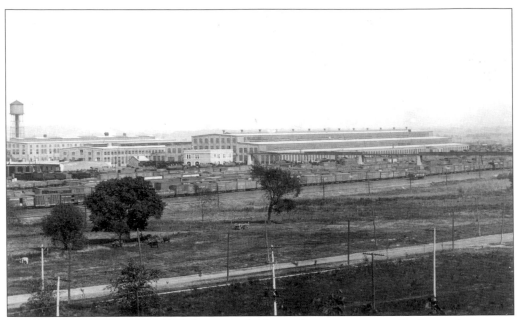

Whether this complex of CRI&P shops was the largest locomotive repair facility in the country or in the world, there was no doubt it was huge. The facility was built between 1902 and 1905, with over 900 acres of buildings and trackage. This area was originally called Pleasant Valley, then New Shops, and finally Silvis, after Richard Silvis, who helped the railroad obtain the land.

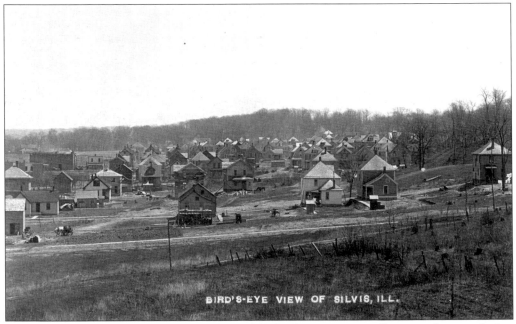

BIRD'S-EYE VIEW OF SILVIS, ILL.

Looking east toward the bluff above Carbon Cliff, this late-1920s view illustrates the growth that was indeed occurring in Silvis housing by this time. There was still plenty of room to grow on the eastern end beyond what is today Ninth Street as well as growth to the south and on top of the bluff.

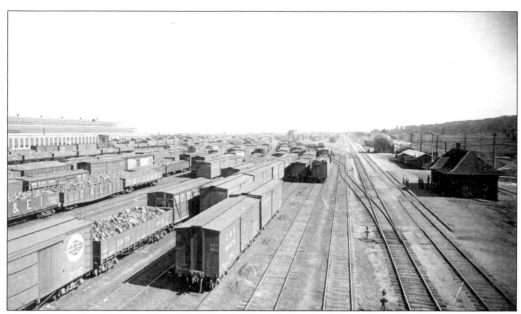

Looking east in this view from about 1915, the expanse of the railroad sorting yard at Silvis can be appreciated. Trainmen and switching locomotives sorted the cars by destination. Later a "hump" yard was built farther east in Carbon Cliff. There, cars were pushed up a gentle slop, and then gravity and switchmen in a tower guided the cars onto the appropriate rails, making up the train.

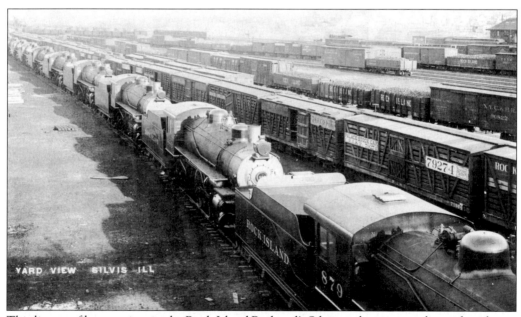

This lineup of locomotives in the Rock Island Railroad's Silvis yards appears to be ready to begin its travels across the railroad's system. Road No. 879, and perhaps the rest of these locomotives, was built by Alco-Schenectady in 1909 but was reworked by the Rock Island Shops in 1917 to make more horsepower. Retirement started for these locomotives in 1935, and the last was removed from service in 1953. (Courtesy of Beverly Coder.)

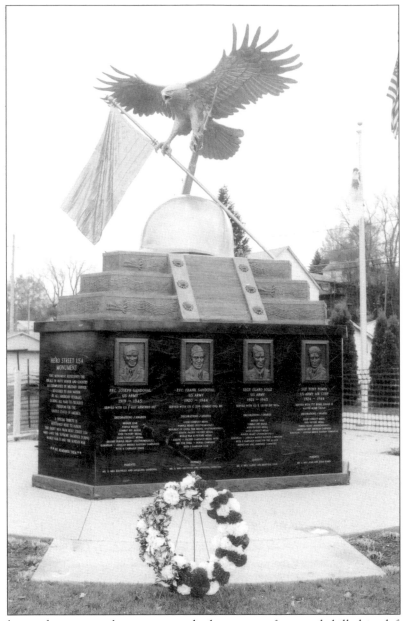

Nowhere else in this country has one street had so many of its youth killed in defense of the United States than Second Street in Silvis. A Mexican American neighborhood of 20 homes, it was less than two blocks long and had a tremendous sense of patriotism. Six of its young men were killed during World War II, and two more were killed in the Korean conflict. In 1969, Silvis town fathers changed the name of that street to Hero Street USA, in honor of those eight young men. The boys' neighborhood playground, called Billy Goat Hill, was dedicated as Hero Street Memorial Park in 1971. A fund-raising committee was formed in 1993 to build a fitting tribute to those eight. On October 6, 2007, this 17-foot-high bronze and granite memorial came to fruition and was dedicated, with friends, families, and members of the armed services as keynote speakers. Over 200 descendants of 32 families along Hero Street USA have served their country in all branches of the armed forces.

Three

HOW THE COUNTY WORKED

The introduction of the combine was a great time-saver for farmers. A combine cut and threshed the grain in one operation and with only one person. The first combines were horse or tractor powered, while today's machines are self-propelled. This early-1950s photograph shows Chester Sample of Coe Township combining a field of oats with his Allis-Chalmers tractor and pull-type combine, definitely more efficient than using the old threshing machine.

P. R. Mitsch and Company established a home furnishings store in 1880 at 1318 Third Avenue in Rock Island. The firm sold over 145 groupings of crockery, glassware, woodenware, toys, notions, and fancy goods. If the store did not have what a customer was looking for, it probably was not available. The building still stands today across from the county jail and is used as a church. (Courtesy of Marcia Anderson Wetzel.)

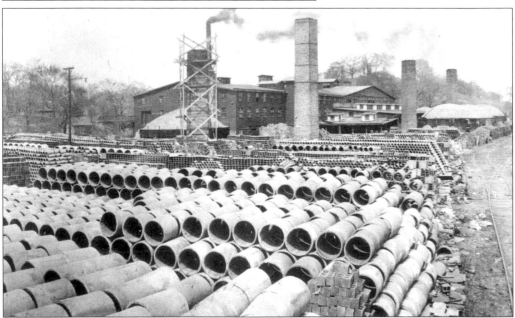

Carbon Cliff received its name from the many coal mines that dotted the bluffs west of town. Those same bluffs were noted for their excellent source of clay. The Argillo Works was formed in 1865 to produce firebrick and farm-drain tile. Argillo's products were sold throughout the country until the 1930s, when fire destroyed the plant's offices and buildings and the firm went out of business.

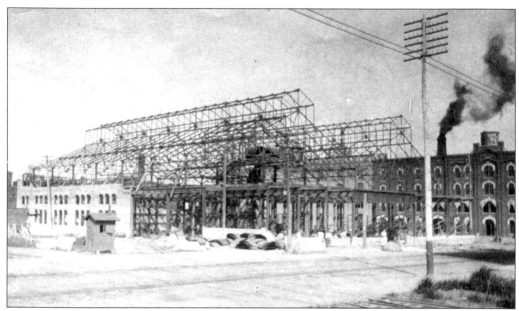

Originally founded in 1865, Candee, Swan and Company was formed to compete directly with John Deere's plow-making operations, the Moline Plow Works. Its catalog of products was nearly an exact copy of Deere's, item for item, including model numbers and prices. The company even copied Deere's trademark. While much wrangling over trademarks, products, and the use of the name "Moline Plow" continued, the company was bought out in 1868 and renamed the Moline Plow Company. During the 1920s, the company changed its name to the Moline Implement Company. In 1929, through a merger, it became Minneapolis-Moline. The 1898 photograph above shows the start of construction on its large, modern plant. The 1910 photograph below shows the completed plant located between Third and Fourth Avenues and Thirteenth and Fourteenth Streets in Moline. The company left Moline in the mid-1950s.

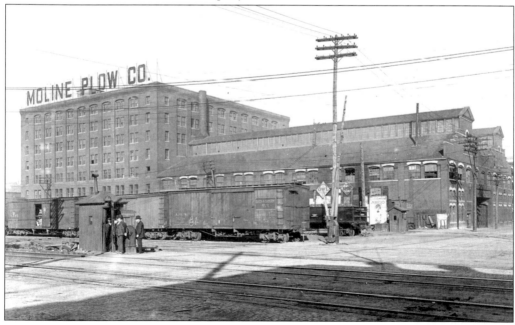

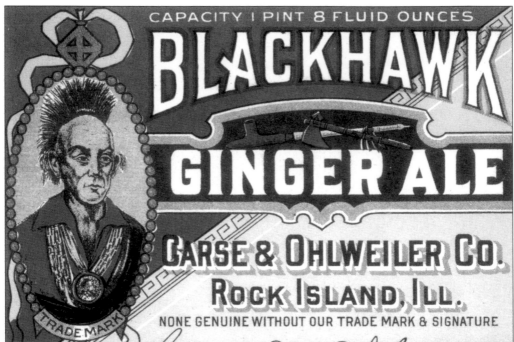

CAPACITY 1 PINT 8 FLUID OUNCES
BLACKHAWK
GINGER ALE
CARSE & OHLWEILER CO.
ROCK ISLAND, ILL.
NONE GENUINE WITHOUT OUR TRADE MARK & SIGNATURE
TRADE MARK

Henry Carse, John Ohlweiler, and John Carse formed Carse and Ohlweiler Bottling Company in 1878. Located at Eleventh Street and Fifth Avenue in Rock Island, the company's bottled cider was considered the best in the area. Many local firms named themselves or their products after war chief Black Hawk. Carse and Ohlweiler Company branded its ginger ale, root beer, and flavored sodas "Blackhawk," as this bottle label illustrates.

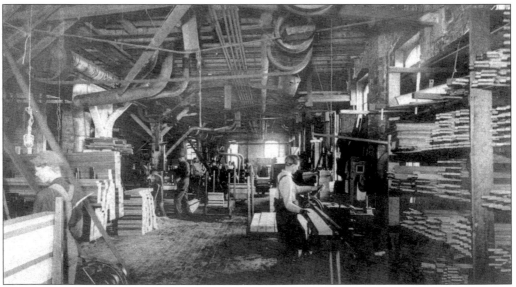

The planing mills of the Weyerhaeuser and Denkmann Lumber Company formed a new subsidiary in 1862, the Rock Island Sash and Door Works. That operation was so successful that it opened branch manufacturing facilities in nine states to supply a wide variety of trim and millwork. Taken around 1900, this photograph shows the custom door and molding shop. Note the belt-driven planers and sawdust collection machinery. (Courtesy of John Wetzel.)

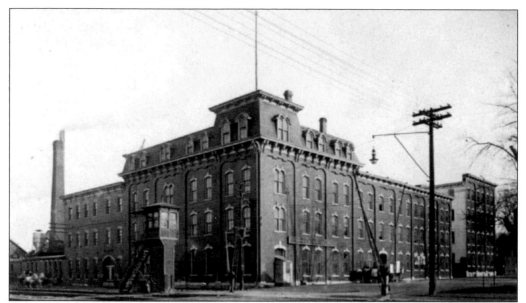

The offices and factory of the Barnard and Leas Company, manufacturers of grain milling equipment, were located at Twentieth Street and Fourth Avenue in Moline. In an era before automated gates at railroad crossings, notice the elevated shack that allowed the guard a clear view up and down the track to watch for trains and lower the gates before they arrived.

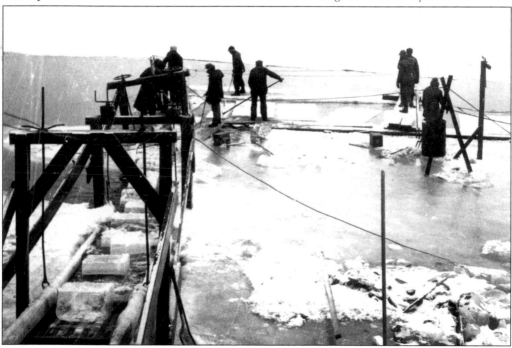

Back in the days of iceboxes, before refrigerators, the Moline Channel Ice Company and other similar firms along the river cut ice during the winter for delivery to homes and businesses in the summer. At Moline Channel Ice, the blocks were stored in sawdust in a building with walls three feet thick for insulation. The company merged with a sand and gravel firm and became known as Moline Consumers.

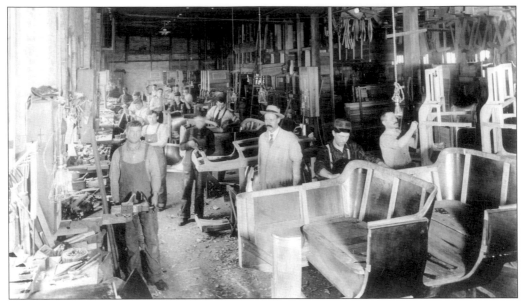

The McLaughlin Body Company name appeared in 1931, but the firm had been manufacturing buggy and automobile bodies since 1902. The 1930s also brought cab manufacturing for General Motors and Diamond T Truck and tractor cabs for Minneapolis-Moline. The first combine cab was built for Deere and Company in 1959. Since that time, McLaughlin has manufactured cabs and body parts for Deere, International Harvester, Mack Truck, and Ford and a variety of cabs for government vehicles.

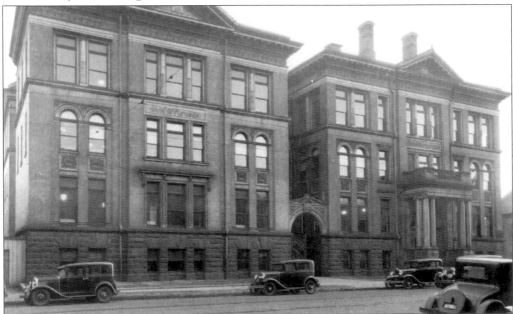

Joseph Root founded Modern Woodmen of America in 1883 as a fraternal benefit society that would protect the financial futures of families upon the death of the breadwinner. Its name came not from the lumber industry but from a parable about woodmen clearing the forests to build homes, communities, and security for families. This building in Rock Island became the headquarters of the firm in 1897. (Courtesy of Modern Woodmen of America Archives.)

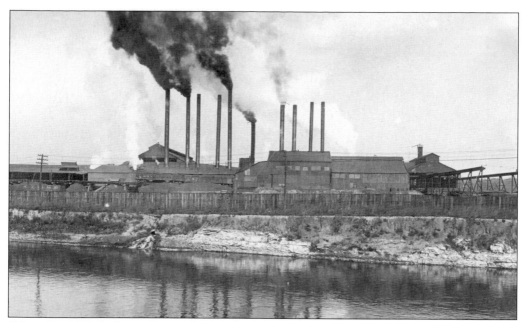

Sylvan Steel Works located on Moline's Sylvan Island in 1894. The island offered plenty of space and abundant water for a sprawling mill that made bar stock for the implement companies. Republic Steel Company took over the plant around 1900 and operated it until 1956. Two of its products were railroad rails and steel fence posts made from rerolled track. Island visitors can walk among a few plant foundations that still exist.

In order to eliminate eastern control of wheel manufacturing, 11 area carriage manufacturers banded together in 1893 to create the Mutual Wheel Company. The firm became a quality supplier of high-grade wooden wheels and spokes. It supplied the area's automobile builders with wooden wheels until steel wheels became common. Still in business today, the company distributes wheels and truck equipment and operates truck service centers. (Courtesy of Mutual Wheel Company.)

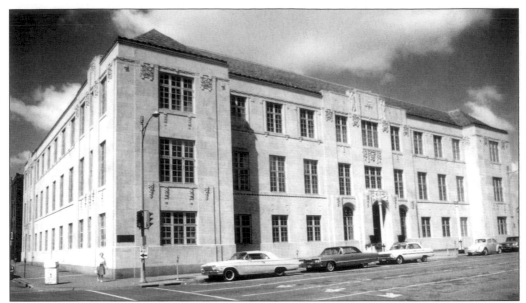

Beginning in 1888 as a ladies auxiliary for the Modern Woodmen of America, the group reorganized into a social organization in 1890. Calling itself Royal Neighbors of America, the name reflected the group's ideals of members helping one another. The idea of forming a fraternal benefit society to provide life insurance protection for women soon garnered support. A charter was signed in 1895, officially forming Royal Neighbors Fraternal Benefit Society. (Courtesy of Royal Neighbors of America.)

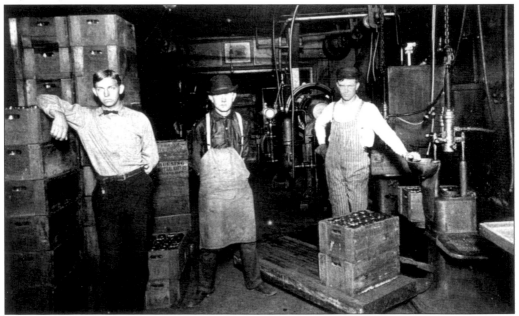

Albert Huesing started a bottling works in 1899 to manufacture and bottle fruit-flavored drinks, sparkling water, and sarsaparilla. In 1902, A. D. Huesing Bottling Works became the local distributor for Anheuser-Busch Brewing. To help keep customers' drinks cold, Huesing built the first ice-manufacturing plant in the area in 1914. The company acquired a Pepsi-Cola franchise in 1935. Huesing still handles a wide variety of Pepsi products throughout western Illinois.

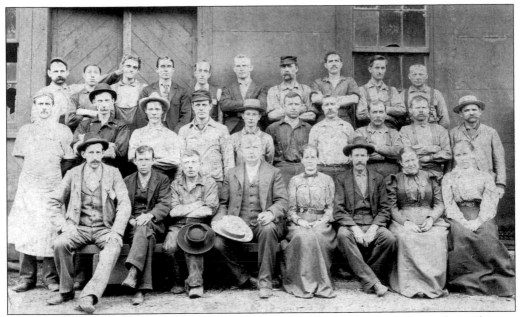

With an order for a freight elevator, Alexander Montgomery founded the Moline Elevator Company in 1892, sharing space in the Montgomery Brothers Machinery Company. Elevator employees gathered for this photograph in 1904. The company was sold to Otis Elevator in 1908. In 1910, he formed Montgomery Elevator, and over the years, it became the fourth-largest elevator company in the country. The firm was sold to Kone Elevator in 1994.

Every carriage and buggy required a harness for the horse that drew it, and harness factories became as plentiful as the carriage factories. The C. J. Cooper Harness Factory began manufacturing around 1890 in this former pail factory owned by Dimock, Gould and Company in Moline. The business flourished until competition from saddle makers and a decline in the carriage trade drove it into bankruptcy and out of business in 1896.

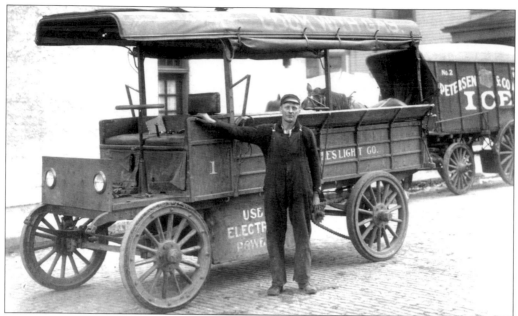

Brothers Thomas and Samuel Davis started Merchant's Electric Light Company in 1884. After further acquisitions of power and light companies in the area, People's Power Company was formed during 1893. It later became known as Iowa-Illinois Gas and Electric Company. It seems only natural that an electric power company used an electric-powered truck for its service work, as this photograph from about 1910 illustrates. (Courtesy of John Wetzel.)

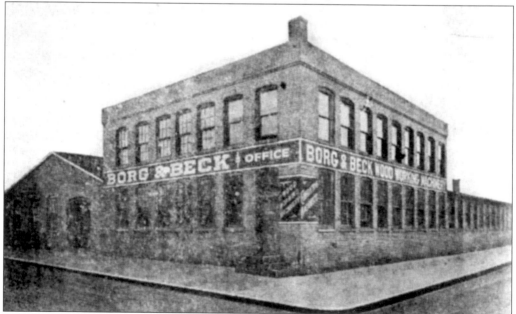

Charles Borg and Marshall Beck launched a woodworking machinery factory in 1903. By 1910, the company was manufacturing a sliding automotive clutch in this factory at Sixth Street and Third Avenue in Moline. Charles Beck's son George and machinist Gus Nelson invented that clutch. As sales grew, production was moved to a plant in Chicago. In 1921, the owners merged Borg and Beck with several other companies, forming today's Borg-Warner Automotive.

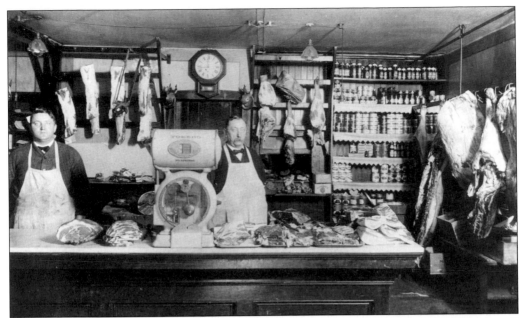

Before the age of the supermarket, it was not uncommon for every neighborhood to have a small grocery or meat market—sometimes both. Of course, modern meat coolers were not common yet, and the meat was usually on display so the purchaser could make his or her choice. Otto Efflandt (right), along with his son William, operated the Efflandt Market in the west-end neighborhood of Moline.

The Rock Island Arsenal was established in 1862 and has manufactured military equipment and ordnance since 1880. One of the items manufactured there was the model 1903 rifle, later known as the Springfield .30-caliber rifle. The workers in this early-1900s photograph of the arsenal firing range were probably the envy of every child and sportsman in the area. They test fired every gun built on the island.

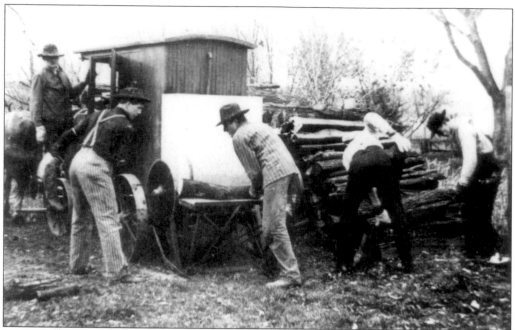

In clearing trees from the farmsteads, farmers would cut and saw logs to a size that could easily be handled by one or two people. Men like the Mathies brothers, shown here, would come to each farm with this machine and saw the logs into firewood-sized pieces. The tractor featured a homemade cab and saw platform, and the saw was belt driven from the tractor's flywheel.

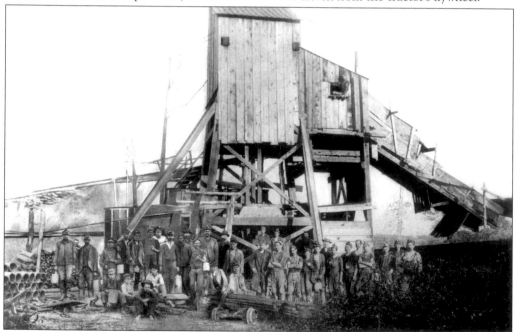

Coal mining was a tough business. Men worked 12 to 16 hours per day, usually six days per week, and were paid by the number of tons they dug each day. Otto Stoehr owned several coal mines in the Coaltown–Carbon Cliff area. This early-1900s photograph shows a gathering of workers in front of the tipple at one of Stoehr's shaft mines. (Courtesy of Don Oppenheimer.)

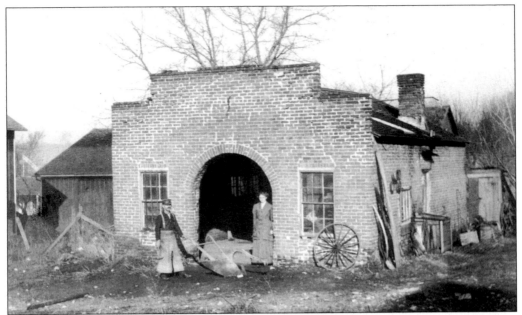

Every town had at least one blacksmith shop. Besides shoeing horses, the blacksmiths had the ability to make or repair plows, metal wheels and rims, springs, harnesses, and tools. Household items like the iron hooks used to hang pots in the fireplace were usually a specialty. This particular shop, photographed in 1912, belonged to Port Byron's blacksmith. Like the corner garage, the shop was a good place to socialize as well.

After Willard Velie bought out Central States Aero Company of Bettendorf, Iowa, he moved manufacturing and assembly to the Velie automobile plant in Moline. Carriage and truck assembly had ended in the building, and there was plenty of room to assemble airplanes. Dealerships were in great demand, and the planes were shipped by the carload. Upon the death of both Velie and his son, the company was sold in 1929.

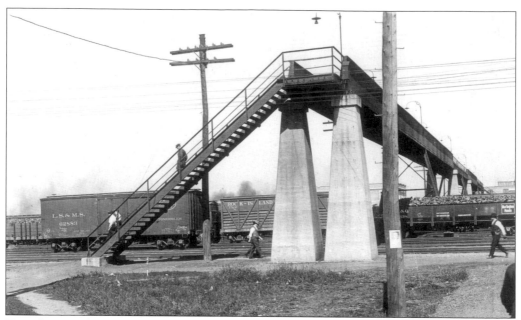

How do several thousand workers get safely to their assignments when working at the Silvis railroad shops? This 1920s photograph displays the pedestrian viaduct used by the shop workers to cross the more than 20 sets of railroad tracks on the south side of the locomotive repair shops. (Courtesy of John Wetzel.)

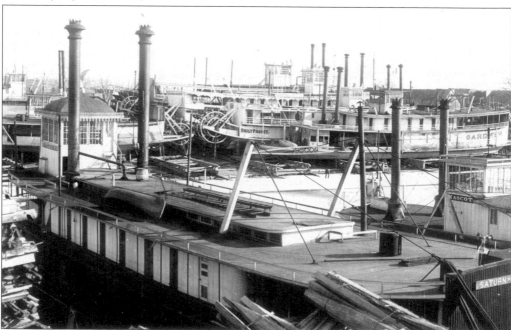

Touted as the largest and best-equipped facility on the upper Mississippi River, the Kahlke Brothers Boatyard began operations in 1863 in Rock Island. At its height, the yard employed well over 500 craftsmen. Known for its quality, the business passed to Peter Kahlke's sons Frederick and Joseph in 1924. Although it ceased major boatbuilding operations during the 1940s, the yard remained open until the death of Frederick in 1975.

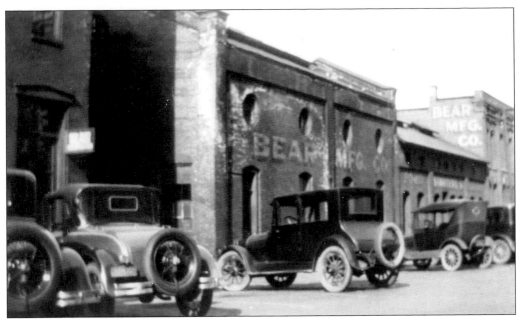

Brothers Will and Henry Dammann created Bear Manufacturing Company to build automobile starter motors for the Ford Model T. When Ford began building cars with starters, Bear switched product lines and became the first company in the nation to manufacture wheel and frame alignment equipment for the automobile industry. Bear's facility was located in the 2000 block of Fifth Avenue in Rock Island.

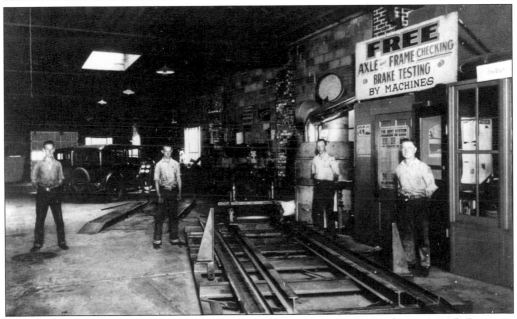

This photograph shows the Bear Manufacturing Company alignment shop in 1925. Bear not only made the equipment but also trained mechanics from around the country in its use. In 1949, the company built an exclusive building for its automotive safety school, which allowed it to train hundreds of students before closing in the 1970s. Manufacturing operations ceased in the 1980s after the sale of the company to Applied Power Industries.

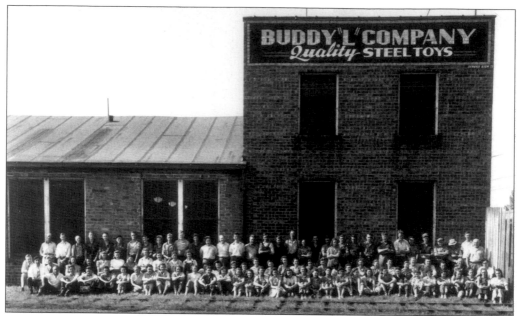

Founded in 1910 in East Moline as the Moline Pressed Steel Company, it originally manufactured stampings for the automobile and farm-implement industries. Owner Fred Lundahl began making toys for his son Arthur Buddy "L" Lundahl from scrap steel. The toys proved so popular that by 1923 the company was only producing toys. The company name was changed to the Buddy "L" Manufacturing Company and produced toys into the 1960s.

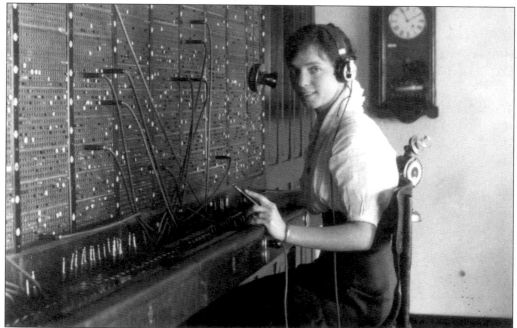

Before direct dialing and cell, push button, and dial telephones, this was how a telephone call was handled. Florence Higgs manned one of the many switchboards at the Central Telephone Exchange in Rock Island during the 1920s. Circuits were connected in exchanges like this to complete local, city-to-city, or long-distance calls.

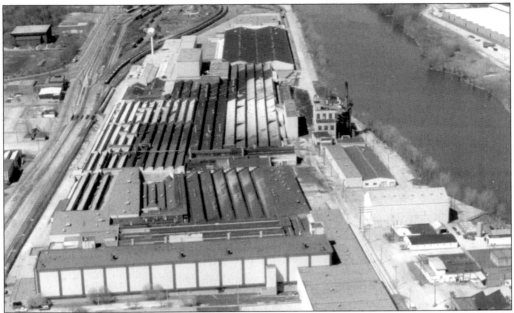

International Harvester Company purchased the Rock Island plant of the Moline Plow Company in 1924. Production of the Farmall tractor began in 1926. Lightweight, row-crop oriented, and affordable, the machines became very popular. As business grew, the plant expanded many times and built over two million tractors during its life. Well over 4,000 workers were employed at the plant before it closed in 1986. (Courtesy of LRC Development.)

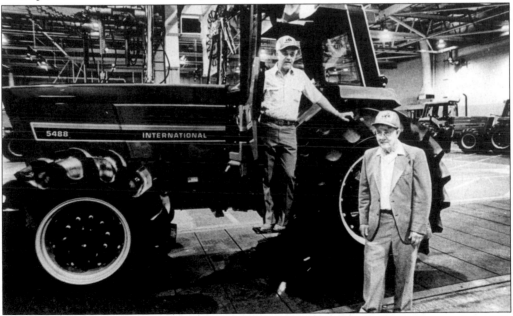

By the time production of Farmall and International Harvester branded tractors ceased in 1985, more than five million tractors had been assembled by the firm. Tractor production began at Rock Island's Farmall Works in 1926, and Herbert Hull (right) worked on the first tractor assembled at the plant. When the last tractor rolled off the line on May 14, 1985, Herbert Hull Jr. was part of that machine's assembly team.

Fred Harrington and Severin Seaberg received a contract to install traffic signals in the Chicago Loop in 1922. Incorporated in 1923 as the Harrington-Seaberg Corporation, the firm began manufacturing municipal signal systems for traffic, fire, and police. When the company became part of the Gamewell Corporation in 1929, Harrington created Harrington Signal Company. He is seen here on the right. (Courtesy of Don Oppenheimer.)

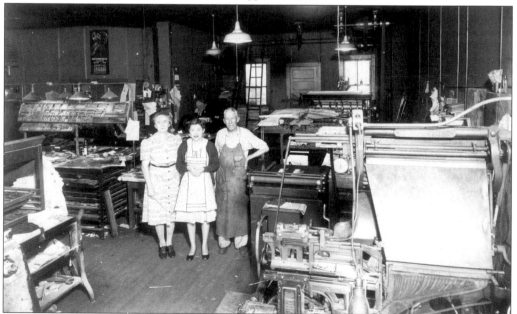

Founded in 1880, the Port Byron *Globe* had a reputation as one of the finest weekly newspapers in the state. It always gave its first attention to hometown and agricultural news of the area. Photographed in the newspaper's pressroom in an era when type was still set by hand, from left to right are longtime employee Myra Gerken and owners Annis and Homer Sell. The *Globe* stopped publishing in 1992.

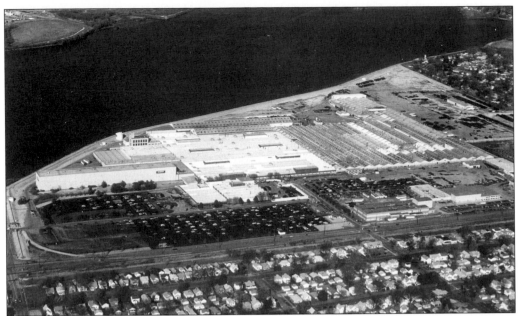

The former International Harvester East Moline Works started life in 1926 as a tractor warehouse for Farmall tractors and a final assembly point for threshers and corn pickers. With over 156 acres of space—58 of those under a roof—the plant produced combines, cotton pickers, planters, grain heads, and cabs. Production ended in 2004 when its owner, Case New Holland, moved production to Grand Island, Nebraska. Today the buildings are gone.

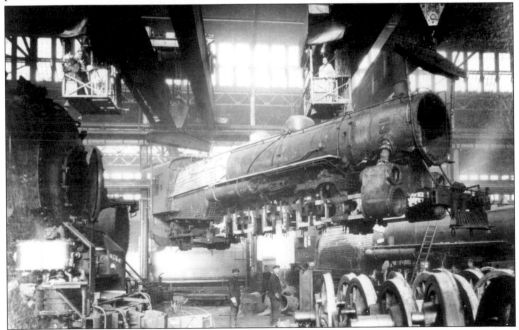

Two giant cranes lift and swing a steam locomotive under repair at the Silvis Shops of the Rock Island Railroad. Three more locomotives can be seen on the left and another on the right in this photograph from 1940. Before closing down in 1980, the Silvis Shops was the world's largest locomotive repair facility. The shops and marshalling yards sat on 900 acres of land.

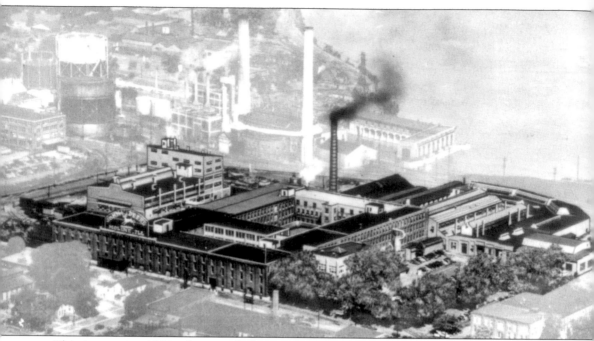

This interesting 1940s photograph from a postcard shows the Deere and Mansur Company complex on Third Avenue in Moline. The Deere and Mansur Company, founded in 1877 by Alvah Mansur and Charles Deere, manufactured implements. This partnership was completely independent of Deere and Company. Among the implements manufactured by the firm were corn planters, cornstalk cutters, seeders, and hay rakes. Corn planters and disk harrows became the major items produced. Mansur, whose original partnership with Deere was through the establishment of a sales branch in Kansas City, left Deere and Mansur in the early 1880s to manage his sales branch in St. Louis. During reorganization in the early 1900s, Deere and Mansur became part of Deere and Company and later became known as John Deere Planter Works. In the background of this photograph are the Moline operations of Iowa-Illinois Gas and Electric Company, and near the top left are some of the buildings of the Republic Steel Sylvan Island Works.

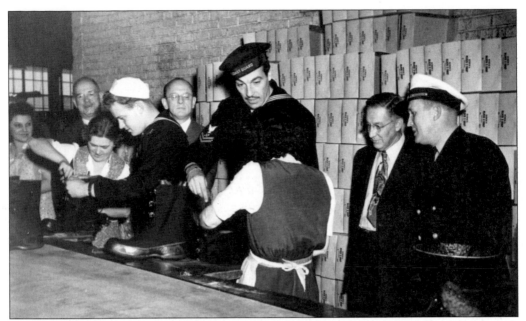

Servus Rubber Company hosted Hollywood film star and leading man Cesar Romero (center). During World War II, Romero joined the Coast Guard and saw service in the South Pacific. At the invitation of the United Service Organizations (USO), Romero and his unit came to Rock Island in 1944 to view the production of boots for the company's government contract. Here Romero's group visits with workers in the packaging department. (Courtesy of Dennis Witt.)

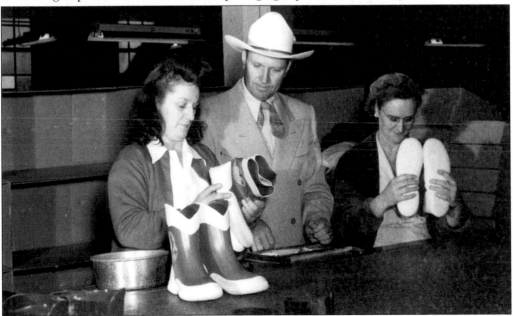

Singer and Western movie star Gene Autry visited Rock Island's Servus Rubber Company several times to create and approve a line of children's boots featuring his likeness. In September 1949, he watches the first boots being inspected before final packaging and shipping. The company began making outdoor footwear in Rock Island in 1922. Today Servus Rubber is part of the Norcross Safety Products group. (Courtesy of Dennis Witt.)

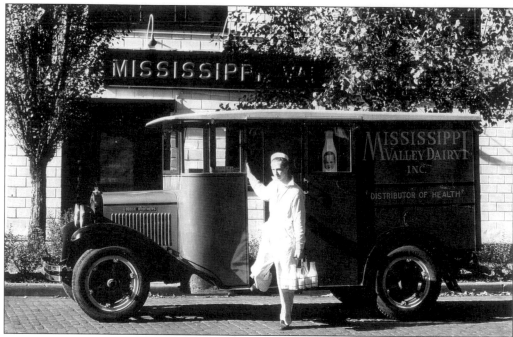

Like the neighborhood grocery, neighborhoods also seemed to have their own dairies. Over time, more than 50 dairies served their various localities with home delivery service. Familiar names like Baker, Clearfield, DeWitte, Downing, Highland, Midvale, Peerless, Sturdevant, and Valley View were among the many smaller firms that brought milk for the family table. The photograph above provides a promotional pose for Mississippi Valley Dairy in Rock Island. The firm was located on Fifth Avenue between Eleventh and Twelfth Streets. The photograph below shows the bottling line at Baker's Dairy on Thirty-fourth Street in Moline. Supermarket pricing helped stop home delivery service, and consolidation and competition from larger dairy firms has stopped local dairy bottling operations throughout the county.

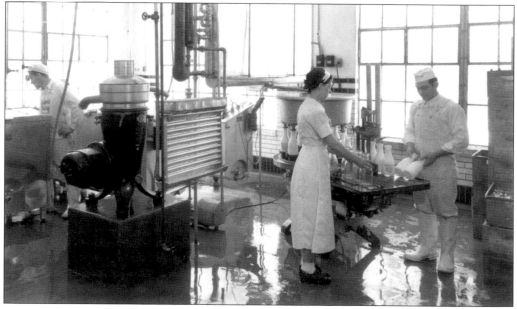

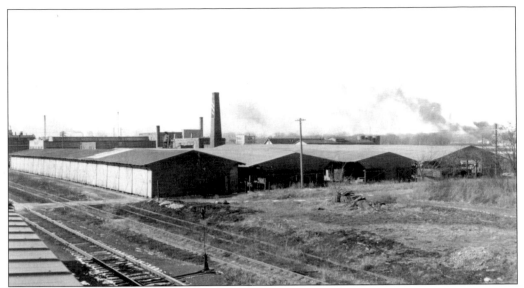

Dewitt Dimock and John Gould began a partnership in 1852 to manufacture woodenware. In 1867, Dimock, Gould and Company erected a lumber mill on Third Avenue and Twenty-second Street in Moline. The woodenware operation was sold in 1890, and the company concentrated on the lumber and pail business, as well as rafting lumber from its extensive timberlands in Wisconsin. This is its Moline yard as it appeared in 1930.

Dimock, Gould and Company was a major supplier of finished lumber, millwork, and building supplies. It operated several lumberyards throughout the metropolitan county. Lined up for this 1952 Moline yard photograph are the Ross lumber carrier, truck fleet, and stacker with drivers. From left to right are Richard VanDamme, Arthur Lofgren, James Johnson, Arthur Jenkins, Cal Lofgren, Rene Grawit, Frank Sansale, Alfred Rich, and Harold Bobb.

The 1950s was a period of infrastructure improvement, and Valley Construction Company provided much of that upgrading. The firm was formed in 1925 as a paving contractor and has become the area's leading general contractor. This photograph from 1955 shows Valley Construction workers leveling the subgrade before paving the ground floor of what became a parking building. This view is from Sixteenth Street looking east between Second and Third Avenues in Rock Island.

Following World War II, William Blaser and his son Stewart were awarded a Nash automobile franchise. Blaser Auto Sales sold that brand until 1956 when the Ford Motor Company awarded the firm an Edsel franchise. The Edsel had many problems. Ford cancelled the brand and bought out dealers across the country. Unknown to the Blasers at the time of their settlement with Ford, they were the last Edsel dealer in the country. (Courtesy of Steve Blaser.)

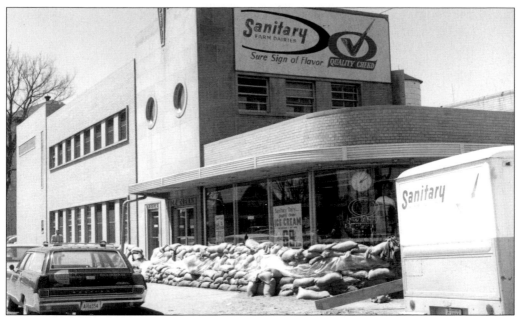

The Anderson Dairy operated in several locations in Rock Island before changing its name to the Peerless Dairy and building this modern-looking office, plant, and dairy store in 1930. During World War II, Peerless reintroduced horse-drawn milk wagons on several routes to save fuel and tires for the war effort. This photograph also shows how the dairy prepared to protect its property during the Mississippi River flood of 1965. (Courtesy of Ted Haines.)

William Hewitt, second from left, chairman of Deere and Company, hosts a trade delegation from the People's Republic of China in the mid-1970s. He was also the vice chairman of the National Council for United States-China Trade. The delegation visited Deere operations in Waterloo and Moline and is shown here reviewing equipment at the Moline proving grounds. The visit resulted in orders for Deere equipment for a new Chinese experimental farm.

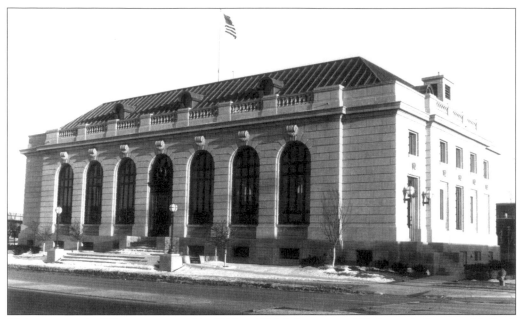

This imposing building was erected in 1910 on Third Avenue and Eighteenth Street as Moline's post office. It was replaced by a new post office on Seventeenth Street in 1935. Montgomery Elevator Company purchased the property for use by its engineering department in the late 1970s. Besides remodeling the interior for office use, the company also refurbished the lobby based on its postal past with antique mailboxes, counters, and clerk's windows.

Iowa State University professor John Atanasoff is credited with inventing the digital computer. Frustrated while trying to find a faster method of making lengthy calculations, he took a long drive. While having a drink at a Rock Island saloon, he came upon the idea of using the binary system for his "calculator." With the help of assistant Clifford Berry and a drink in Rock Island, the Atanasoff-Berry computer was born in 1938.

98

Four

HOW THE COUNTY CELEBRATED

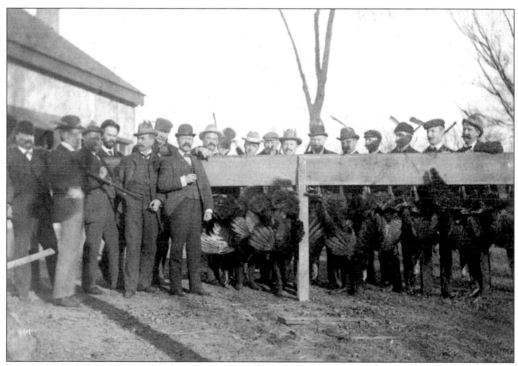

Members of the Marlin Rifle Club gather outside their clubhouse for this 1898 photograph and to display the results of their turkey shoot. Stationary target-shooting competitions were held throughout the year, but the turkey shoot was the most popular and was held every fall at the club's headquarters, located on the grounds of the Huber Brewing Company at Thirtieth Street and Seventh Avenue in Rock Island.

The Hillsdale Fair drew attendees from around the upper county, but especially from Zuma, Coe, and Canoe Creek Townships. One of the attractions at this late-1890s fair was the "farmers' footrace." Surrounded by well-dressed onlookers at the starting line, these barefoot participants happened to be the officers of the fair. The gentleman on the right, apparently acting as the starter, was the fair president.

John Hauberg was instrumental in founding many organizations within the county. Some had serious intentions, and some were just for fun. This 1892 photograph displays the Sugar Hollow Fire and Drum Corps. The group played political rallies, Sunday school picnics, and various town celebrations. From left to right are John Hauberg, Herbert Quick, August Eipper, Ernest Denhardt, Raymond Quick, and Louis Hauberg.

Many commercial firms of the late 1880s sponsored marching bands to perform at company and public events. The Deere Cornet Band was formed to display employee pride in both the company and the community. John Deere cared deeply about not only making quality products but also supporting his employees and community. This fine band was just one of the many community activities supported by Deere.

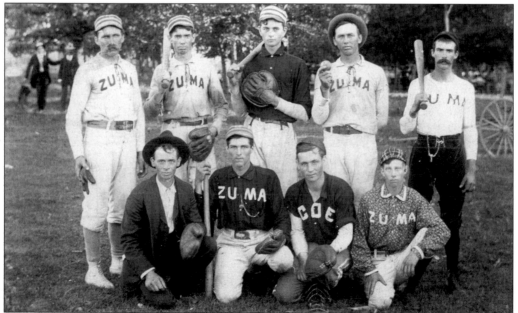

Long before modern-day forms of entertainment were invented, farmers' picnics allowed people to come together to enjoy fellowship, catch up on news of the area, and have some friendly competitions. Representing Zuma Township at this 1899 picnic was this group of young baseball players. The photograph does beg the question whether the Coe Township player snuck into the picture or was a ringer for the boys from Zuma.

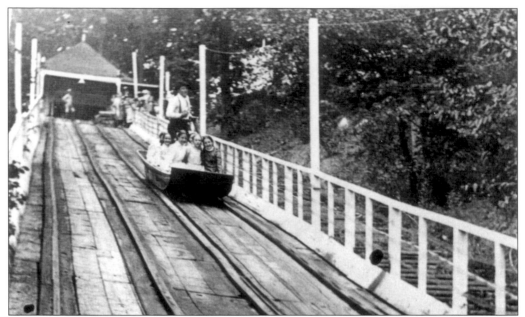

The amusement park at Black Hawk's Watch Tower featured a shooting gallery, roller rink, bowling alleys, and a roller coaster. By far the most popular ride was the Shoot the Chutes. Patrons rode a flat-bottomed boat down this wooden slide and were launched out onto the Rock River below. The man standing at the rear was the tender who steered and paddled the boat back to shore.

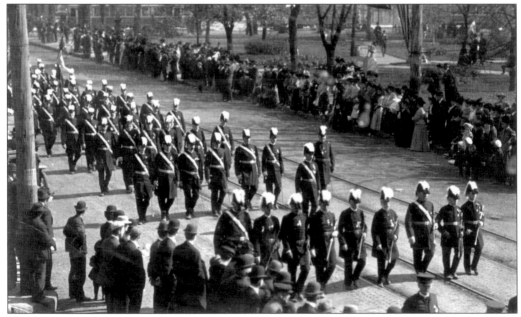

While brief in nature, the Spanish-American War helped replace the scars of the Civil War by uniting Northerners and Southerners against a common foe. It also helped form friendships among the soldiers. In 1904, the Spanish-American War Veterans was formed to honor the soldiers who served and to remember the end of hostilities. Local members of the group march past Rock Island's Spencer Square during an encampment in the early 1900s.

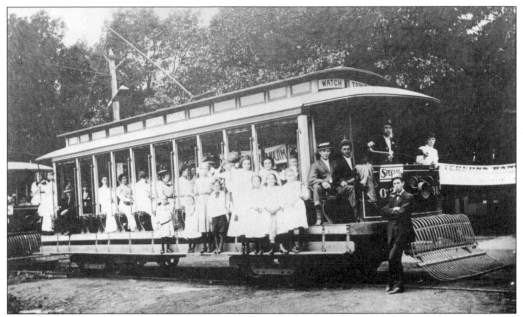

Picnics and outings provided to company employees or customers is not a modern idea. With the Watch Tower amusement park as a destination and the trolley to take people there, what better place to throw a party. This early-1900s photograph depicts the Milan *Independent* newspaper outing for its employees and readers at the park. Extra trolley cars had to be added to carry the large crowd.

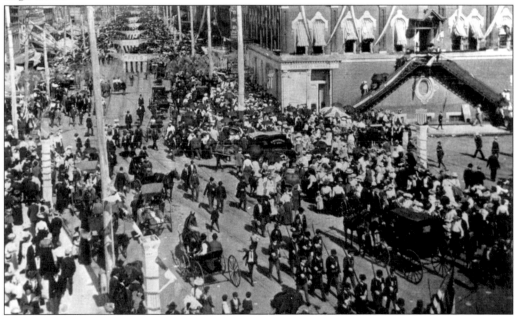

Union veterans of the Civil War formed the Grand Army of the Republic (GAR), first for camaraderie and then for political power, in 1866. The local organization was called a post, and a department consisted of all posts within a given state. Large crowds turned out for all the gala of the 1902 GAR encampment held in Rock Island. Usually multiday affairs, they included camping out, elaborate dinners, and memorial events.

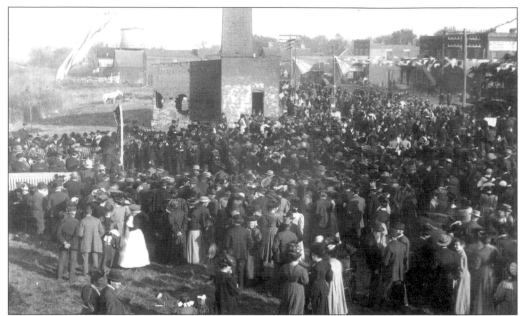

The completion and opening of the Hennepin Canal called for a grand celebration. That is exactly what happened on October 21, 1907, when nearly 10,000 visitors came to downtown Milan for the gala event. Festivities included several military bands, a river carnival, a variety of team racing events, free boat rides on the canal, concessions, a chorus of steamboat whistles, and fireworks at night.

The Moline Commercial Club was established in 1895 by Charles Deere to further the commercial interests of the city. The group met in private homes until it built its own building in 1912 on the southwest corner of Fifth Avenue and Sixteenth Street. It served as both a meeting place and, as the billiard room illustrates, a social hall. The club disbanded during the Depression. (Courtesy of John Wetzel.)

A sense of curiosity always brings spectators to fires or accidents. A group of Port Byron residents looks over the results of this accident at the iron bridge over Barber's Creek. This People's Power Company truck almost made it across the bridge. Perhaps too heavily loaded, the bridge gave way with the truck landing on a rock ledge on the north side of the creek. Reportedly no one was injured.

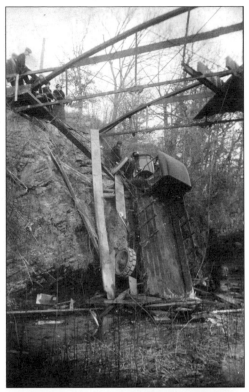

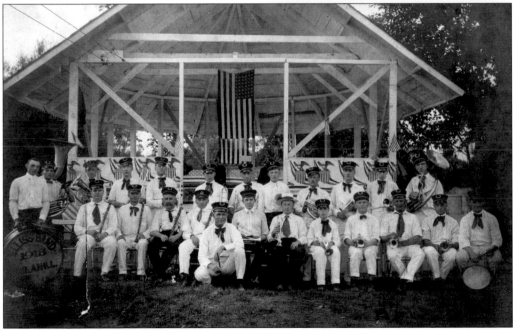

Band concerts were great forms of entertainment wherever they were held. Edward Ellis, director of the Milan Band, organized the group in 1917. The band staged musical programs every Wednesday evening during the summer months at the Milan bandstand. The timbers used to construct that bandstand had come from the town's collapsed water tower.

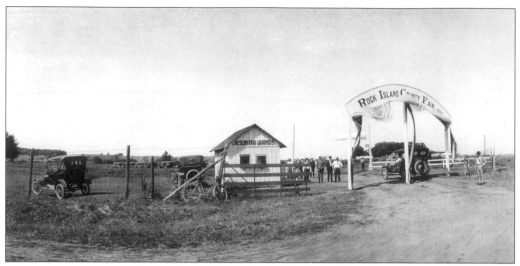

A group of farmers from Coe and Canoe Creek Townships formed a board in 1890 to create a fair for the upper county. Martin's Grove in Zuma Township near Hillsdale was the chosen site and became known as the Joslin Fairgrounds. The first fair was held in 1893 with harness racing a favorite event. In the late 1920s, the fair was phased out due to financial difficulties.

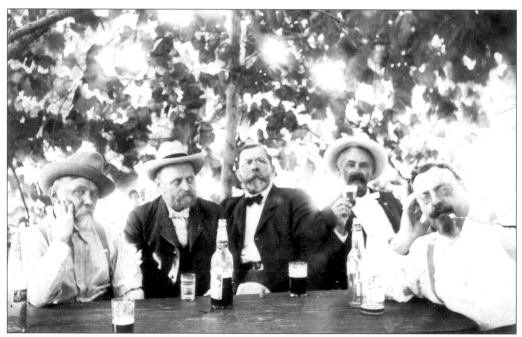

With several brewing companies and an untold number of home brewers in the county, a spot of beer was not hard to find. Many local saloons also featured outdoor beer gardens. Luchman's Tavern in Rock Island featured one such garden. These gentlemen are enjoying an afternoon of gossip and beer. From their looks and demeanor, perhaps they have enjoyed the afternoon a little too vigorously.

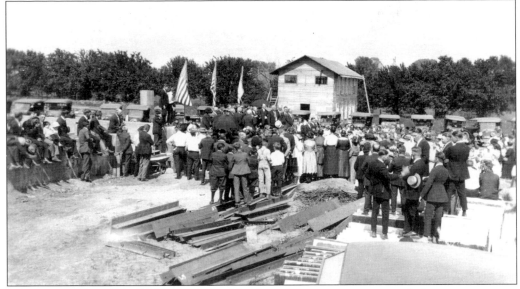

When an event such as the laying of a building's cornerstone occurs, a crowd always turns out to celebrate. Hillsdale High School broke ground in 1920 and opened the following year. By 1956, the Hillsdale schools had become part of the Riverdale Community School District and high school students attended class in Port Byron. The former high school building became a junior high for seventh- and eighth-grade students.

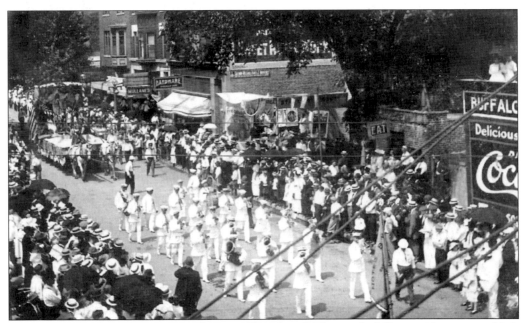

Fr. John Culemans, pastor of Sacred Heart Church in Moline, asked Honore Note to establish a band to help recreate the St. Cecilia's Day festivals that were popular in the Flanders area of Belgium, former home to many of the church's parishioners. Note's band became very popular and participated in many community events, such as this Fourth of July parade on Moline's Sixth Avenue near Fifteenth Street around 1922.

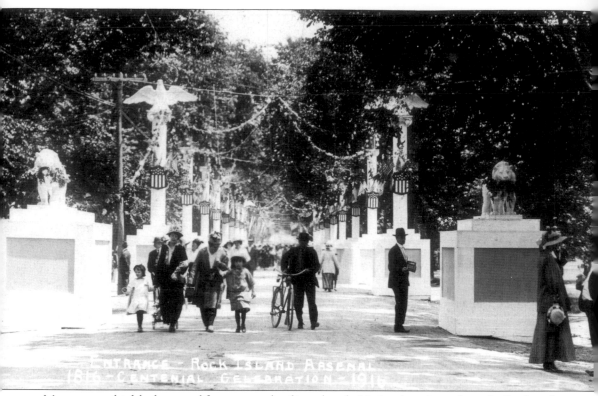

ENTRANCE - ROCK ISLAND ARSENAL
1816 - CENTENNIAL CELEBRATION - 1916

Monuments, highly decorated floats, several military bands, Native Americans from the Sauk and Mesquakie tribes, and speakers from the U.S. Army were highlights of the centennial celebration of Fort Armstrong in 1916. Planned by the Rock Island County Historical Society, the event took place over three days. Both Rock Island County and Scott County (Iowa) celebrated the event with parades. Each day, another parade wound through a city and culminated on Arsenal Island. Pres. Woodrow Wilson participated as well. He pressed a button at the White House that illuminated a light and signaled an army band to initiate the festivities. The centennial also noted the founding of the fort by erecting and dedicating a replica of Blockhouse No. 1 near its original site along the southwestern shore of the island. The blockhouse remains today and welcomes visitors to the west arsenal gate and the U.S. Army Corps of Engineers offices.

John Hauberg organized the Black Hawk Prairie Club in 1920 but changed its name in 1923 to the Black Hawk Hiking Club so it would not be confused with another prairie club. Outings were arranged up to a year in advance. A leader was chosen for each hike, and a hike was never cancelled due to weather. Plants and animals were not to be disturbed. The club still exists today.

It might be difficult to tell who enjoyed these limousines more—the chauffeurs who drove them or the gentry who rode in them. It also seems unusual that this 1920s photograph caught the drivers for three well-to-do families lined up at George Sohrbeck's Pharmacy on Fifteenth Street in downtown Moline at the same time. For years, Sohrbeck's was a popular drugstore used by the city's more affluent residents.

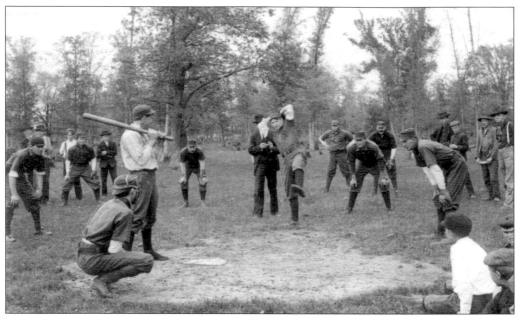

Since the 1800s, baseball has been the national pastime. A variety of leagues were formed to accommodate the wide interest in both playing and watching. City park boards also provided an outlet for competition. This early-1900s photograph appears to have been posed for the camera since everyone is so close to the infield, or else the team on defense thought the batter could not hit the ball very far.

Baseball was a popular pastime throughout the county, and nearly every town had a team. The Hampton Regulars, although not affiliated with any particular company, were members of the Industrial League. Since no industrial firm supported the team, a collection was taken at each game to help purchase uniforms and equipment. All good players, team pitcher Bill Coder even received a tryout with the Chicago Cubs. (Courtesy of Jack Coder.)

Many communities fielded semiprofessional baseball teams until the Depression years. Milan had a long baseball history. Team members of the 1928 Milan Independents, from left to right, are (first row) Bill Wright, George Willhite, Harry Wilson, Al Brust, Irving Taylor, and Edward "Pap" Crosby; (second row) Wendell Clark, Paul Wilson, Henry Hodson, Harold McQuaid, Ben Hodson, Herschel Criswell, Guy Hodson, Virgil Clark, Homer Smith, and Russel Maucker.

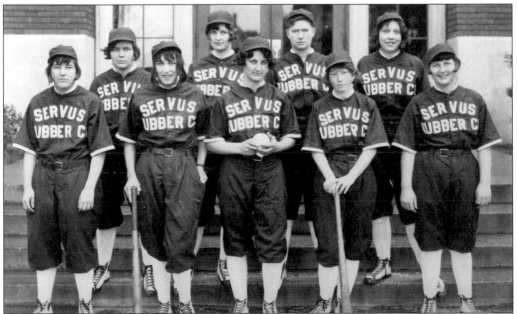

Various companies organized teams to compete in league competitions. The Servus Rubber Company fielded this fine team in the Rock Island Girls' Softball League in the late 1920s. Members of the team, from left to right, are (first row) Helen Taube, Clara Ludwig, Ann Starr, Beulah Raisbeck, and Florence Brennan; (second row) Mary Bedford, Mabel Brennan, Margaret Peters, and Theo Wannack. (Courtesy of Dennis Witt.)

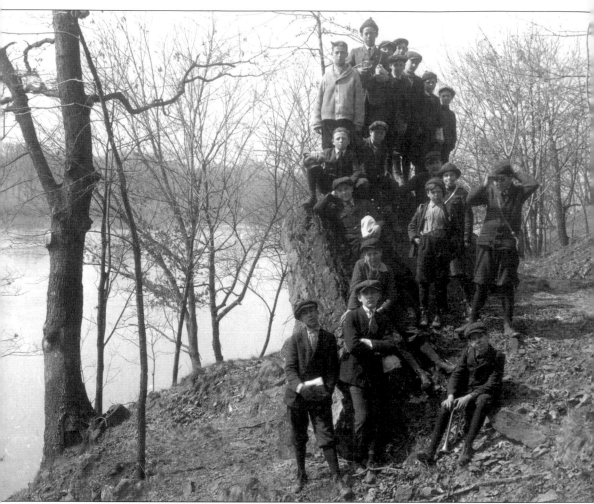

Having a deep interest in the youth of the county, John Hauberg created the United Sunday School Boys Band in 1909. It was a fife, drum, and bugle corps designed to be an incentive for young boys to attend Sunday school. The band was originally designed for the boys at Rock Island's Mission House, but popularity in belonging to the group grew so great that Hauberg made it interdenominational. Any boy could join, as long as he went to a Sunday school. The band marched in parades and gave many area performances. As an added attraction, the group took weekend and longer summer hikes. Every year, there was a lengthy trek of two to three weeks in duration, aided by wagons and trucks. With Hauberg, the boys hiked, climbed, cooked, and slept in the outdoors. When on a hike, the boys still attended Sunday school and marched from camp to a nearby community church. The group disbanded in 1923.

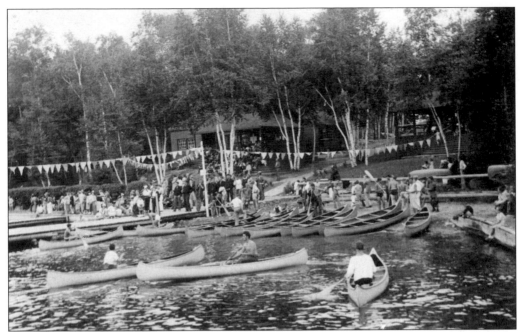

Camp Hauberg, the YMCA camp, was the site of many activities such as this rowing regatta around 1930. Hauberg, a local historian and philanthropist, jointly donated river land south of Cordova to the Rock Island and Moline YMCAs for use as a boys' camp. A large dining hall and guesthouse were built for use by not only the camp but also many other nonprofit groups.

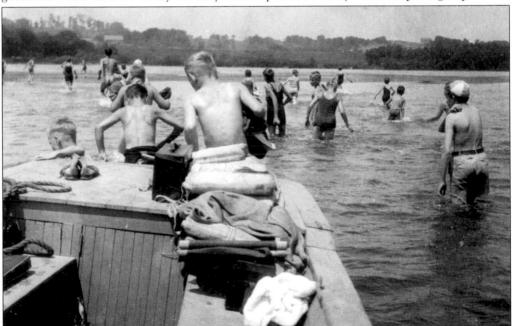

Before the system of dams was built on the Mississippi River in the 1930s, low water usually made the many rock formations and sandbars in already-low river channels that much more accessible. These boys appear to be heading for one of those river sandbars, easily seen in the upper center of this photograph, and a cooling swim off the shore of Camp Hauberg.

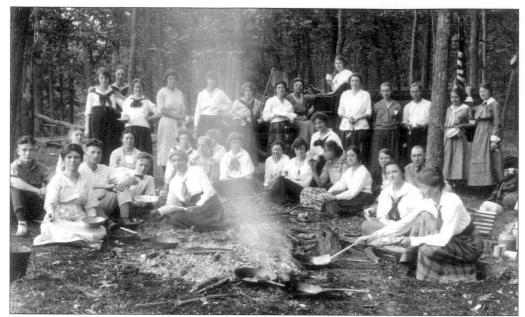

A group enjoys a cookout on the grounds of Archie Allen's Place, the YWCA camp near Port Byron. Allen settled on river land, naming it Canaan. He was a trader, ferry operator, and sawmill operator at Port Byron. Allen was also the first mail carrier on the Fort Armstrong-to-Galena route. Suzanne Denkmann Hauberg purchased Allen's property in 1921 and donated it to local YWCA groups.

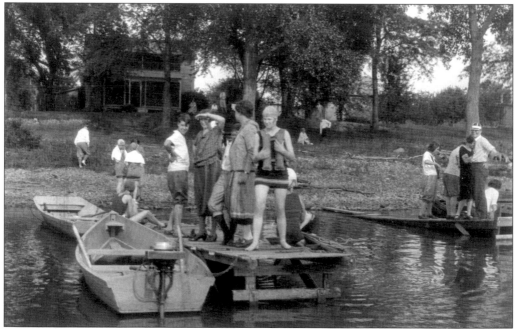

Also called Camp Archie Allen, the YWCA camp was a great place to enjoy summer river activities, as this photograph from 1930 indicates. The YWCA provided swimming and boating safety classes at the camp. It also joined in many activities with its upriver YMCA neighbor, Camp Hauberg. The former home of pioneer settler Allen is in the background.

With a history that starts in the late 1820s, the village of Hampton was officially organized in 1838 and became one of the main steamboat ports in the county. This 1938 photograph shows a group of celebrants during Hampton's centennial parade on First Avenue stopped in front of Fulscher Hall. First Avenue was originally a Native American trail and later a stage trail upriver to Galena. (Courtesy of Beverly Coder.)

Founded in 1905 by William Meese and other key community leaders, the Rock Island County Historical Society's main goal was, and still is, the collection and dissemination of the county's history. This 1940s photograph displays an outing of the society's membership at Loud Thunder Forest Preserve in Buffalo Prairie Township. Evidently it was more enjoyable to serve a meal cooked over a campfire than to have one catered.

First National Bank of Rock Island celebrated the opening of the first drive-up teller in the late 1940s. Driving through the alley to the bank's back wall was certainly not glamorous by today's standards, but customers appreciated the convenience offered by the bank. After the bank erected a new building in the 1950s, its drive-up teller lanes took up a half block.

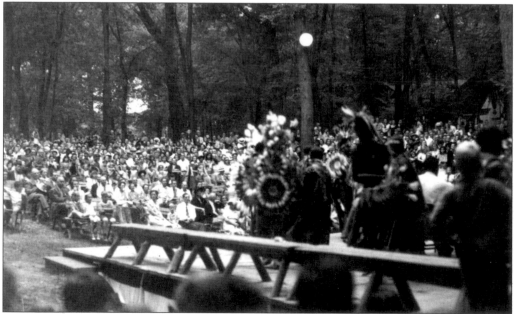

John Hauberg was instrumental in the creation of the Black Hawk Historic Site in 1927, and he provided many of the Native American relics for the museum built in 1937. Hauberg also established an annual powwow in 1940. The event brought Mesquakie Indians to the park to demonstrate their dances and customs. Thousands attended the yearly event, but waning funds signaled the end of the festival in the early 1980s.

In the 1940s, a variety of organizations offered not only a social outlet but also the opportunity for providing a public service. This group of Bowling Township ladies comprised the Pleasant Ridge Red Cross Sewing Circle. They met every Tuesday evening during World War II to help the Red Cross with sewing services.

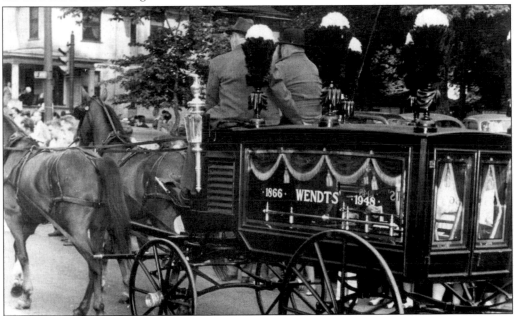

The Wendt Funeral Home was first organized in 1866 at Port Byron and opened a Moline location in 1929. This photograph from Moline's centennial parade in 1948 shows the horse-drawn hearse used by the funeral home in years past. While modern funeral coaches are formal, they do not match the stylishness of this antique carriage. Note the plumage on the roof and the draping in the side glass.

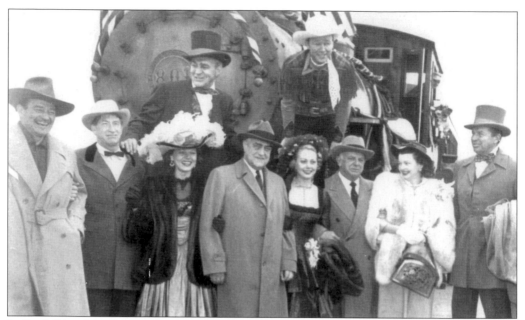

In Rock Island for the April 1950 premiere of the *Rock Island Trail*, from left to right, are John Wayne, Chill Wills, Adrian Booth, Forrest Tucker, unidentified, Adele Mara, Roy Rogers, unidentified, Dale Evans, and Bruce Cabot. All were under contract to Republic Pictures. Reportedly Republic Pictures paid so cheaply that junkets of this type were perks of employment for Wayne, Rogers, and Evans. (Courtesy of Fred Marzolph and Buck Wendt.)

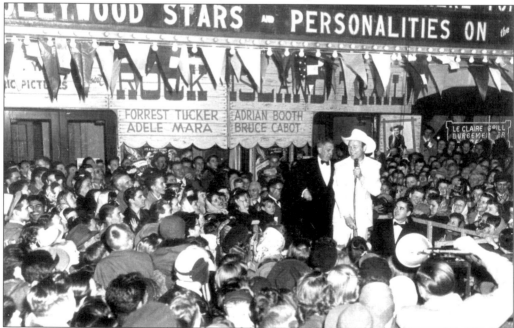

Bring a famous Hollywood star to town and look how the crowds turn out. Following a parade that started in Silvis and ended in Davenport, cowboy star Rogers greeted this large crowd at Moline's LeClaire Theatre, one of several theaters screening the film *Rock Island Trail* on premiere night. (Courtesy of Fred Marzolph and Buck Wendt.

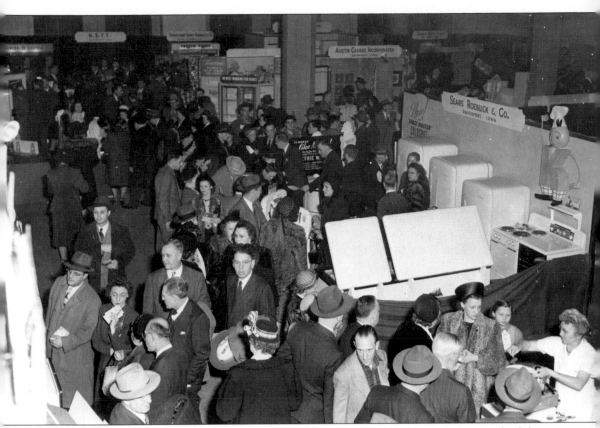

Entertainment took a variety of forms over the years. Besides movies, concerts, nightclubs, and sporting events, commercial exhibits were also popular and well attended. In addition to displaying the latest merchandise, these exhibits also allowed a variety of local manufacturers the opportunity of showcasing their products to make the buying public aware of what was available. The home show was a staple of the early 1950s. Department stores displayed their furniture, drapes, carpets, and accessories in model rooms. Plumbing firms furnished kitchen models with the newest-styled fixtures. Contractors even built small-scale houses to present their designs and talents. This photograph from the 1951 home show illustrates its popularity as the crowd views the latest products. The photograph also shows how customs have changed over the last 50 years. Note how well the attendees are dressed compared with similar events of today. (Courtesy of John Flambo.)

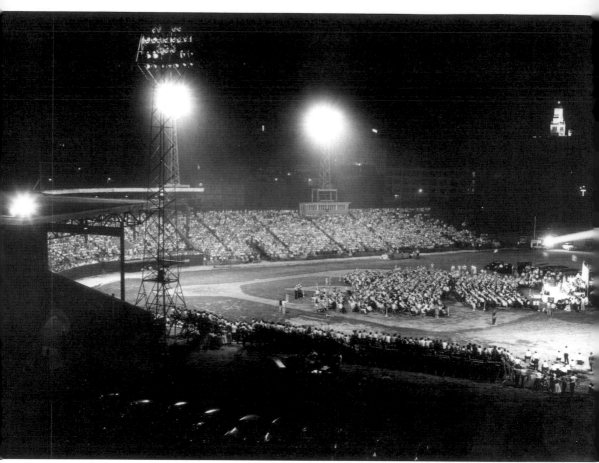

Moline radio station WQUA hosted ABC Radio star Don McNeill and his *Breakfast Club* in August 1955. LaVerne Flambo, owner of the station, brought big-named talent to the area for years. As the *Breakfast Club* was the most popular program on the station, it seemed a natural for an excellent station and sponsor promotion. For the troupe's appearance, Flambo rented a large houseboat and had the stars of the show travel down the Mississippi River from Clinton, Iowa. When the boat reached Moline, antique cars awaited the McNeill group for a huge parade to Davenport and the Davenport Municipal Stadium. The stadium was used, as it was the only permanent facility that could hold the expected crowd. More than 10,000 came to see McNeill and his entertainers present a *Breakfast Club* show in the evening. Eagle-United Food Stores of Milan cosponsored the event. (Courtesy of John Flambo.)

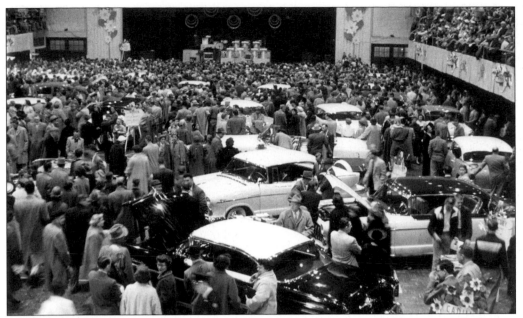

For several years, the Quad City Automobile Dealers Association held new car displays at the Rock Island Armory. The shows not only featured the year's new models but top-name entertainment as well. Entertainers like Pat Boone, the McGuire Sisters, the Four Lads, the Crew-Cuts, and the Eddy Howard Orchestra all made appearances. Attendance averaged 25,000 for each of the four years that shows were produced. (Courtesy of John Flambo.)

The McGuire Sisters are shown with Verne Flambo (left), owner of WQUA and general manager of the Autorama, and Vern Trevillyan, president of the Quad City Auto Dealers Association. Flambo offered the trio $6,000 and 60 percent of the gate receipts as pay, but the sisters wanted their $8,000 contract fee. Had they listened to Flambo, they would have made $20,000 for their appearances at the show. (Courtesy of John Flambo.)

Only the Rock Island Armory and Moline's Wharton Field House were large enough to hold crowds of 3,000 to 6,000. Many revue-type programs drew that many audience members to those two venues. One popular act that played the area several times was the Harmonicats. The trio offered not only good music but also comedic choreography with their act. (Courtesy of John Flambo.)

Fishing the waters of the Mississippi and Rock Rivers was a favorite pastime of many county residents. Orville Meyers, former president of the Quad City Conservation Club, displays a good day's catch along the Sylvan Slough. Meyers and friend Harry DeLeon were among the first to broadcast hunting and fishing tips on radio and television. Their show, *Along the Outdoor Trails with Porky and Ponce,* aired for over 20 years.

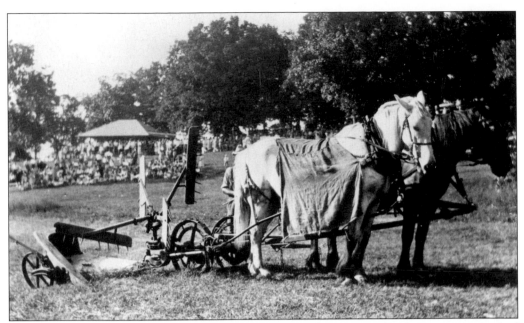

Unlike today's farmers with their advanced computerized equipment for planting, cutting, and harvesting, farmers of times past had to do those chores by foot and with horsepower. At the Coe Township centennial celebration in 1957, attendees are shown a demonstration of how hay was harvested in the late 1800s with this team of horses. The township was originally named Fremont, then Penn, and then Coe in 1858.

Rock Island hosted a grand welcome home celebration for Hollywood actress, singer, and city native June Haver in 1947. Mayor Melvin McKay assists Haver in making an impression of her feet in cement outside the entrance to the Fort Theatre. The impression square can still be seen today in its original location in front of the Fort, now called the Circa 21 Dinner Theatre.

Similar to horseshoes, rolle bolle was a favorite game of Belgian immigrants that caught on with many non-Belgians. The bolle was turned from wood with a cambered edge that would allow it to travel in an arc. Bolders tried to lean or touch the bolle against a stake at the opposite end of the court. Teams from taverns and social clubs were prevalent throughout the area in the mid-1950s.

Called the Sky Ridge Observatory, it was the product of a longtime hobby in astronomy by Moline businessman Carl Gamble. Located off Coaltown Road in Moline, the observatory welcomed many youth groups to gaze at the stars in the 1950s. Upon Gamble's death, the telescope and dome were donated to Augustana College, where they became the principal element of the John Deere Planetarium. (Courtesy of Curt Roseman.)

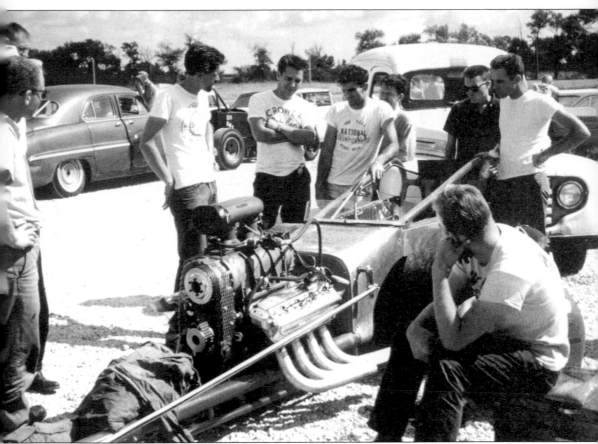

One of the first and longest-operating drag strips in the country is the Cordova Drag Strip. Now known as Cordova Dragway Park, it was built just north of town in 1955 to give young hot-rodders a place to safely race their cars. Since 1957, the track has been home to the World Series of Drag Racing, the oldest continuous drag racing event in the world. This photograph was taken at the World Series in the early 1960s. The three men standing in the center, from left to right, are Sid Seeley, owner of the dragster; Jeff Coyne, who supplied some of the speed equipment on the car; and Don Garlits, nationally known drag racer and holder of many speed and elapsed-time records. Seeley became known as the "Moline Madman" due to his use of a 90 percent mixture of nitromethane racing fuel and his no-holds-barred style of driving. He was one of Cordova's more popular racers, and the fans loved to watch his smoky runs down the quarter mile. (Courtesy of Orin Rockhold.)

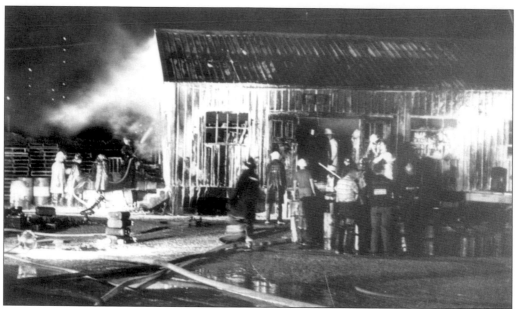

Ten local businessmen who played cards at Moline's central fire station felt they might be able to assist the fire department on some better level. With permission of the fire chief, those men formed the Moline Second Alarmers Association in 1952. Their mission was to help at extra alarm fires by running for tools, helping clean up after a fire, and washing hose back at the firehouse. The group still exists, but today they fill breathing air bottles from a mobile cascade truck and provide rehabilitation services on the firemen at the fire scene. In the photograph above, a group assists with clean up at an oil company warehouse fire. The photograph below caught members Charlie DeWitte, Ken Lemaster, and Tony Sorgen as they prepared the group's 1948 Seagrave pumper for a birthday party fire truck ride.

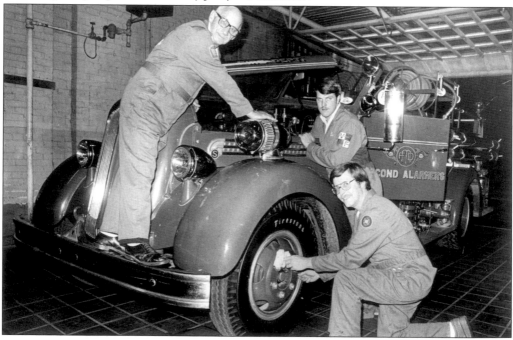

The Rock Island County Historical Society was organized in 1905 by William Meese to preserve the history of the county. While the society was interested in artifacts, its main thrust was to archive documents and the oral and written histories of the settlers and pioneer families. The society met in various locations until 1960, when Mrs. Charles Deere Wiman donated the former Atkinson-Peek house for use as a permanent home and museum. The archives outgrew its second-floor room, and a library was created in the basement of the house museum. Conditions were not ideal, as the photograph above depicts. To house the collection properly, funds were raised, and a library addition was added to the house in 1992. As the photograph below shows, the society now has a proper facility for its ever-growing files on the history of Rock Island County.

ACROSS AMERICA, PEOPLE ARE DISCOVERING SOMETHING WONDERFUL. *THEIR HERITAGE.*

Arcadia Publishing is the leading local history publisher in the United States. With more than 3,000 titles in print and hundreds of new titles released every year, Arcadia has extensive specialized experience chronicling the history of communities and celebrating America's hidden stories, bringing to life the people, places, and events from the past. To discover the history of other communities across the nation, please visit:

www.arcadiapublishing.com

Customized search tools allow you to find regional history books about the town where you grew up, the cities where your friends and family live, the town where your parents met, or even that retirement spot you've been dreaming about.